ART OF DRAWING
MANGA

PROFESSIONAL

DRAWING

CLASS

Art of Drawing Manga

Text
SERGI CÀMARA
Drawings
VANESSA DURÁN
Additional Drawings
LYDIA TUDELA
Book Design
JOSEP GUASCH

Translated from the Spanish by Michael Brunelle and Beatriz Cartabarria

Library of Congress Cataloging-in-Publication Data available
10 9 8 7 6 5 4 3 2 1

Published in 2007 by Sterling Publishing Co., Inc.
387 Park Avenue South, New York, NY 10016
Copyright © 2006 Parramón Ediciones, S.A. Ronda de Sant Pere, 5, 4th floor 08010 Barcelona (Spain)
First published in Spanish: *El Dibujo Manga*
English translation copyright © 2007 by Sterling Publishing Co., Inc.

Distributed in Canada by Sterling Publishing
c/o Canadian Manda Group, 165 Dufferin Street
Toronto, Ontario, Canada M6K 3H6
Distributed in the United Kingdom by GMC Distribution Services
Castle Place, 166 High Street, Lewes, East Sussex, England BN7 1XU
Distributed in Australia by Capricorn Link (Australia) Pty. Ltd.
P.O. Box 704, Windsor, NSW 2756, Australia

Printed in China.
All rights reserved

Sterling ISBN-13: 978-1-4027-4706-9
 ISBN-10: 1-4027-4706-3

For information about custom editions, special sales, premium and corporate purchases, please contact Sterling Special Sales Department at 800-805-5489 or specialsales@sterlingpub.com.

ART OF DRAWING
MANGA

Sterling Publishing Co., Inc.
New York

Con-tents

Introduction

It is obvious that manga has gained many followers among Westerners. However, its first steps were not easy. While the aficionados—initially young people—were thrilled by the new stories and enjoyed them, thus contributing to the rapid expansion of the medium, parents and educators formed part of the most critical sector and argued that its content was full of sex and violence. This was due in part to the fact that many of the titles chosen by Western editors reflected that content. It was also criticized that graphically all the artists creating manga were like clones, lacking artistic personality and knowledge of the huge variety of styles and genres, again because the editors were just concentrating on a very small part of the extensive Japanese body of work. Despite all these setbacks, manga ended up finding an important niche among a heterogeneous and loyal public, thus demonstrating that many artists have unique talents and personalities. With respect to the content, it was also evident that the range is so wide that there is no theme, social or professional sector, or human and cultural tendency that does not have its story adapted to manga.

The graphics and narrative of manga are evolving constantly. At the same time, the diversity of themes on which the stories are based is increasing on a daily basis. This is without a doubt the reason why the number of followers worldwide is on the rise. It could also mark a decline of the traditional Western comic.

Presently, in the Western world, the influence of the manga style is reflected in the style of drawings made by children or young people, which resembles creative drawing as a vehicle of expression. Illustrations created by Gerard Càmara (age 8).

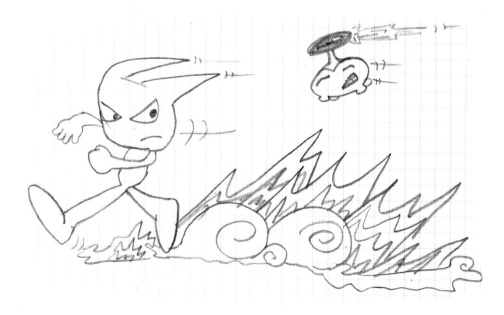

When we speak of "manga style" we refer to a way of depicting stories, both graphically and narratively, that is being assimilated by Western readers. It is even favorably influencing many artists, some who readily adopt this style and others who incorporate some of the formulas of manga into their usual storytelling method, for example, the "Nouvelle Manga" in France or the increasing number of North Americans being inspired by Eastern aesthetics. This book demonstrates the great variety of graphic possibilities, as well as the most essential aspect of manga—its narrative.

A few decades ago, the children and young people who ventured into creative drawing did it influenced by the graphic styles of Walt Disney, Hergé, André Franquin, Uderzo, and Chuck Jones, among others. Nowadays, those influences have changed to Akira Toriyama, Yumiko Igarashi, CLAMP, Katsuhiro Otomo, and Hayao Miyazaki, among others.

Sergi Camara

Born in Barcelona, Spain, in 1964, the author has worked in the world of cartooning and illustration since 1981. In 1987 he created his own production company, Studio Camara, where he carries out his work as a producer, scriptwriter, director, creator, and animator.

Through his production studio he has collaborated on more than 50 television series and feature films and has even directed his own production series, which has been successfully distributed in more that 130 countries.

Enthusiastic and curious about any form of graphic expression, written or audiovisual, he became interested in the world of manga and anime and made his own incursions into the medium; this book is one of the results.

Presently, he is developing new projects for animation series, and he writes and illustrates children's books for several publishers in Spain, England, and the United States.

Vanessa Durán

Vanessa was born in Santiago de Compostela, Spain, in 1972. She published her first professional work Uno entre un millón (One in a Million) at age 24, after earning a degree in Fine Arts and being awarded the first national Spanish Manga award by FICOMIC.

As a freelance and manga illustrator, she has contributed to many Spanish and foreign magazines, newspapers, and fanzines, including the books in the series Mangamania by Christopher Hart of the United States and the role book Big Eyes, Small Mouth for Guardians of Order of Canada.

Presently she contributes regularly to the magazines Itaii Itaii and Shade.

The His- tory of Manga

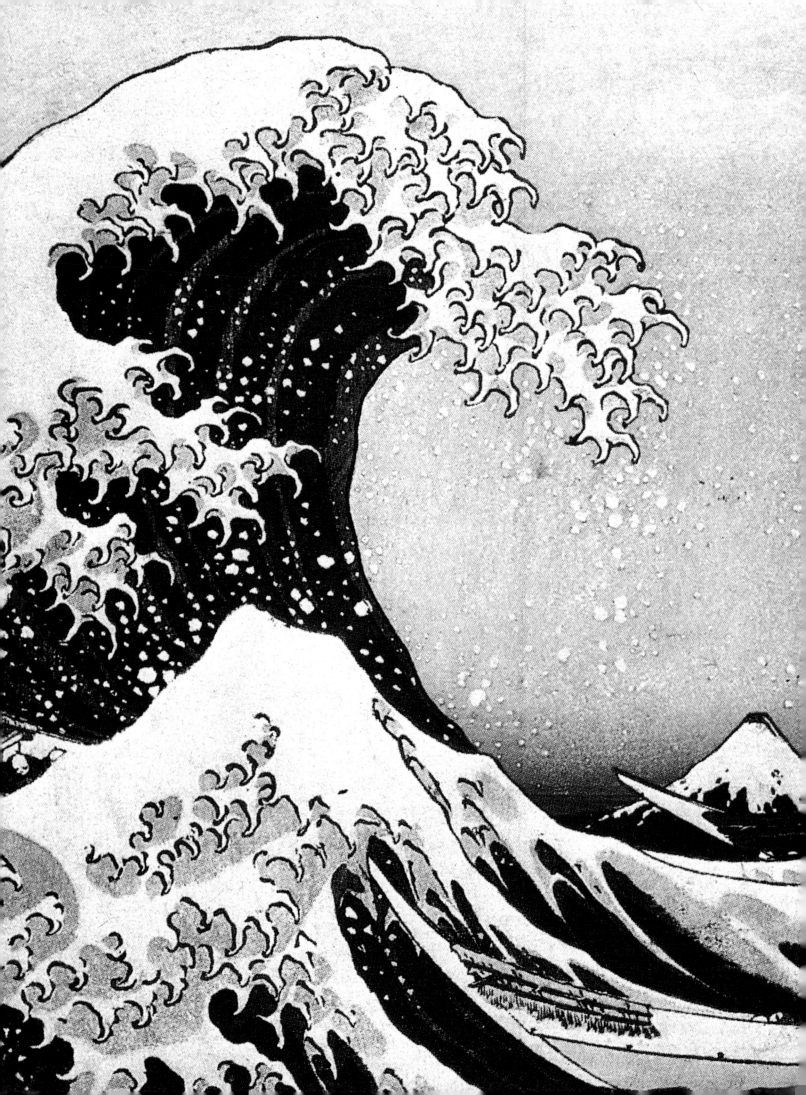

The Origins

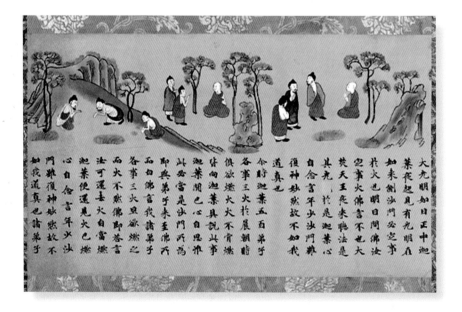

E-INGAKYO. FRAGMENT OF A WORK COPIED IN JAPAN BETWEEN THE YEARS 753 AND 756.

of Manga
are found in the art
of illustration that originated

in China around the 6th century and that was introduced in Japan in the 7th century. The first example is a scrolled painting known as *E-Ingakyo (Illustrated Sutra of the Causes of the Present and Past)* from the year 753. The inspiration for it comes from Chinese painting, but it actually originated in India, expanded to China, and then migrated to Japan with the expansion of Buddhism in the 12th century. During this period, a sentiment of national identity called *Yamatizante*, opposing the influences of Chinese painting, was born in Japan. This gave way to Japanese *Emaki* art and to *Choju-Giga*. The term "manga" did not surface until 1814, when it was used by the painter Hokusai Katsuhika. In his work *Hokusai Manga*, the painter fused the words *man* (spontaneous, whimsical, distorted) and *ga* (drawing, painted, or printed image). The result was "whimsical drawing" or "spontaneous image."

The Predecessors
of Manga as It Is Known Today

although these works are a far cry from the current manga, the Asian tradition of including texts in graphic representations is the predecessor of what centuries later would become Japanese cartoons.

THE *EMAKI-MONO*

Also known as *Makimono*, these scrolls are an art form that began in the Heian (749-1192) period and lasted through the Kamakura (1192-1333). They consist of horizontal scrolls of varying lengths between 30 and 40 feet (9 and 12 meters) containing anecdotes, material of a literary or religious nature, representations of battles, romantic tales, folklore, or supernatural stories. The scrolls are read horizontally from right to left.

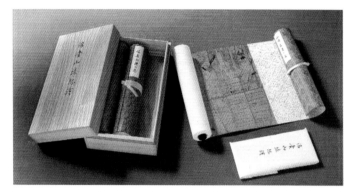

Emaki-Mono *preserved rolled up in its box.*

Fragment of the Shigisan-Engi-Emaki (Legend of the Monk Shigisan), *from the second half of the 12th century. This* Emaki-mono *represents a rice silo rising up in the air in a village through the influence of the monk Shigi. The caricature-like expression of the villagers surprised by the phenomenon can be appreciated.*

Fragment of a Choju-Giga *attributed to the priest Toba. The scrolls depict animals engaged in human-like activities.*

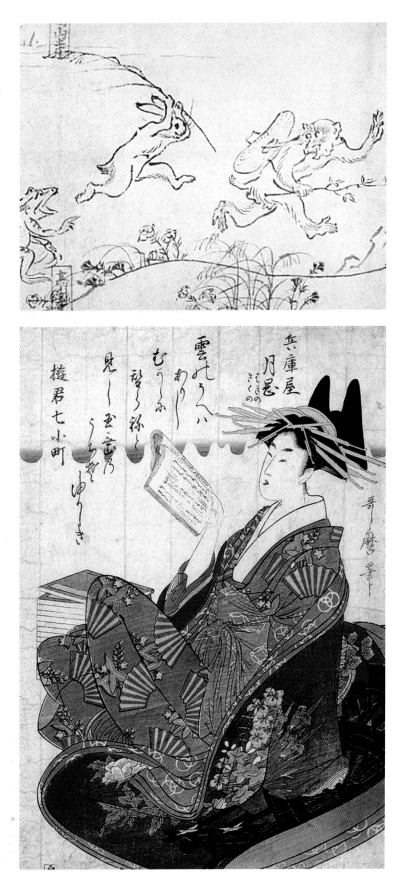

THE *CHOJU-GIGA*

Also in scroll form, the *Choju-Giga* appeared in the 11th century; this time they are monochromatic and executed with a brush. They are attributed to a priest named Toba (1053-1140). Their content is satirical in nature and similar to fables, since they display anthropomorphic animals engaged in human activities, together with priests involved in play and in rooster fighting. At the beginning, the *Choju-Giga* (funny drawings of animals) were reserved for the religious and aristocratic sectors. Five centuries later the art expanded and became popular in all sectors of society.

THE *UKIYO-E*

This art form existed from the end of the 17th century (1680) until the 19th century (1868). The *Ukiyo-E* (art of the floating world) consists of prints carved on cherry wood blocks. The most recurring themes are the experiences in the pleasure neighborhoods of Edo (ancient Tokyo) and in other urban areas. The prints include courtesans, prostitutes, scenes in bathhouses, teahouses, and brothels, and *Kabuki* theater scenes. With the *Ukiyo-E* an important market of great popular demand was created for fashion illustrations, congratulatory cards, illustrated books, pornography, and so forth. Their creators looked for social satire beyond aesthetic perfection, and in their pictorial fantasies, they offered relief to people in a time of oppression and social discontent resulting from feudal dictatorship.

Kitagawa Utamaro (1753-1806) was one of the most well-known representatives of the Ukiyo-E *school. He is famous for his portraits of sensual female beauties.*

One of the 15 volumes of the book Hokusai Manga. *The term "manga" appeared for the first time at the beginning of the 19th century.*

HOKUSAI KATSUHIKA

Hokusai was one of the greatest champions of the *Ukiyo-E* print school. He was the author of a series of prints known as Fugaku Sanjurokkei (36 Views of Mount Fuji), created between 1826 and 1833 and also of a series of 15 volumes used as painting teaching methods (*gafu*).

Hokusai was the grand master of these books. His most famous work, *Hokusai Manga*, went into publication in 1814 and was not finished until 1878, after the artist's death. In the middle of the 19th century, his prints were imported to Paris, where they were being collected enthusiastically, especially by Impressionists such as Claude Monet, Edgar Degas, and Henri Toulouse-Lautrec, whose work exhibits the strong influence of those prints.

The Great Wave Off Kanagawa, *from the series Fugaku Sanjurokkei (36 Views of Mount Fuji).*

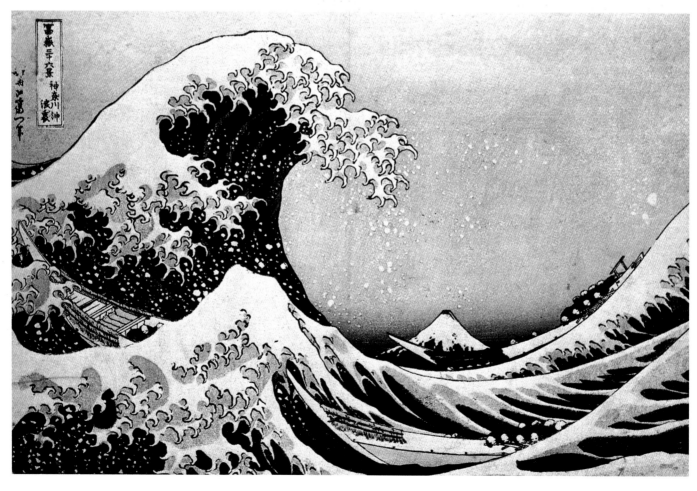

INTRODUCED 7th C. Japan

MANGA - " (WHIMSICAL) DRAWING
DISTRACTED SPONTANEOUS } PAINTED OF PRINTED
ORIGINATED IN INDIA IMAGE
EXPANDED TO JAPAN
W/ EXPANSION of Buddhism in 12th C.

term " Manga " 1814
used by HOKUSA KATSUSHIKA

" WHIMSICAL DRAWING "
SPONTANEOUS / IMAGE

THE BIRTH OF MANGA

At the beginning of the 19th century, the traditional Japanese isolationism created by Western colonialism began to crumble. With the Treaty of Kanagawa (1854), the commodore of the United States Navy, Matthew Calbraith Perry, proposed the opening of Japan to the Western world, allowing American ships to anchor along the Japanese coast and to trade with that country. Within a few years other Western nations gained the right to trade with Japan. This event contributed to the modernization of the country and helped it to achieve international stature; and as a result the *shogunato* began to decline. All these events facilitated the contact of Japanese artists with Western creators, some of whom, such as Charles Wirgmann (1835–1891), a British journalist for the *Illustrated London News*, established in Japan in 1857, traveled to the islands. In 1862, Wirgmann launched the publication of a monthly magazine fashioned after British humor, *The Japan Punch*, intended for foreigners who lived in Yokohama. The publication was active until 1887 with an approximate run of 22 issues. Wirgmann's satirical caricatures did not spare Japanese people, who were exposed to the printed form of modern caricature for the first time. *The Japan Punch* was also translated into Japanese.

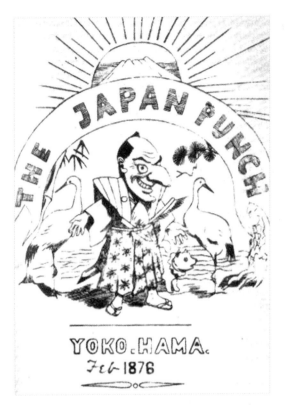

Cover of the magazine The Japan Punch, *published by Charles Wirgmann in 1862.*

At the beginning of the 19th century, Japan broke its traditional isolationism allowing other nations to trade with the country and, as a result, welcoming cultural influence from all fronts.

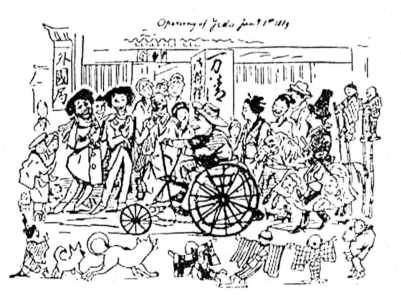

One of the drawings by Charles Wirgmann for his magazine The Japan Punch.

Cover of the magazine Tôbaé, created by Georges Bigot in 1887.

BEGINNINGS OF FOREIGN INFLUENCE

In 1882, another foreigner by the name of Georges Bigot (1860-1927) arrived in Japan from France to teach modern art at the school for Army officials. He published his own magazine in 1887, *Tôbaé*, in honor of the famous priest Toba, author of the *Choju-Giga* from the 11th century. This also was a satirical publication, which caused him many problems with the authorities; however, for many Japanese artists, it triggered a change in attitude with regard to the, until then, noncritical and subdued behavior toward power.

RAKUTEN KITAZAWA

One of the first and best-known authors of true manga was Rakuten Kitazawa (1876-1955). He studied painting in the United States and, as the sole Japanese artist involved, helped to create the North American magazine *Box of Curios*. When he returned to Japan in 1899, he worked as a caricaturist for the *Jiji Shimpo* newspaper's supplement *Jiji Manga*, a title that caused the term to become generalized to designate caricatures created in Japan. In 1901 he created the first manga with steady characters, *Tagosaku to Mokube no Tokyo Kenbutsu* (The Journey of Tagosaku and Mokube to Tokyo), where the text continued to be written as a caption instead of using the subsequent dialog balloons.

Kitazawa is attributed with the publication of the first Japanese comic magazine, *Tokyo Puck,* in 1905, which reached a run of 100,000 copies. The texts for the captions were written in English, Chinese, and Japanese.

Japan was introduced to manga by the hand of Kitazawa. Throughout the 20th century, it developed along the same lines as Western comics, that is by focusing on political and social criticism.

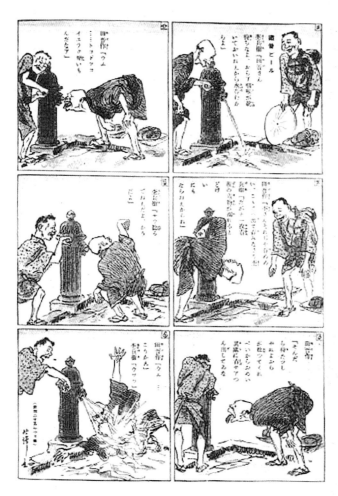

A page of Tagosaku to Mokube no Tokyo Kenbutsu *(1901), the first series of Japanese manga with steady characters.*

Cover of the magazine Tokyo Puck *(1905).*

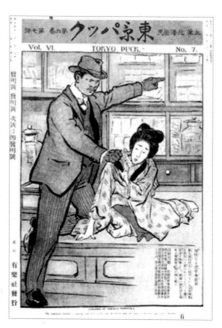

Right. Front page of an edition of The Jiji Shimpo, *the first Japanese newspaper in which there was a supplement dedicated to manga* (Jiji Manga).

the expansion of manga took place through newspaper supplements, weekly publications for adult audiences, and magazines for children and adolescents, such as *Shonen Club* (1914), devoted to boys, *Shojo Club*, for girls, and *Yonen Club*, for children.

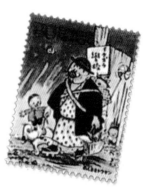

Nonkina Tousan (1924) by Yukata Aso. This character became so popular that in 1999 it was used on a postage stamp.

The Consolidation
of Manga in Japan in the 20th Century

THE TWENTIES

In the 1920s, the first characters that became very popular made their appearance. This was the case of *Dango Kushiuke Man yû (Chronicles of the Dango Kushiuke Journey)*, a work by Shigeo Miyao, published in 1922 in the magazine *Maiyu Shimbun* and *Sho Chan no Boken (The Adventures of Little Sho)*, drawn by Katsuichi Kabashima and with texts by Oda Shosei, published in 1923 by the journal *Asahi Graph*. The stories of Sho-Chan were probably the first manga that was adapted to anime in 1924. That same year, the stories of *Nonkina Tousan (The Optimistic Dad)*, by Yukata Aso and geared toward an adult audience, made their appearance in the journal *Hochi Shimbum* and constituted the first modern strip of Japan. The series lasted until 1950, and its popularity made it possible to have its own merchandising and a movie adaptation produced in 1928, directed by Hakuzan Kimura, one of the pioneers of Japanese anime.

Illustration by Shigeo Miyao, one of the pioneers in the creation of manga characters that became popular in Japan.

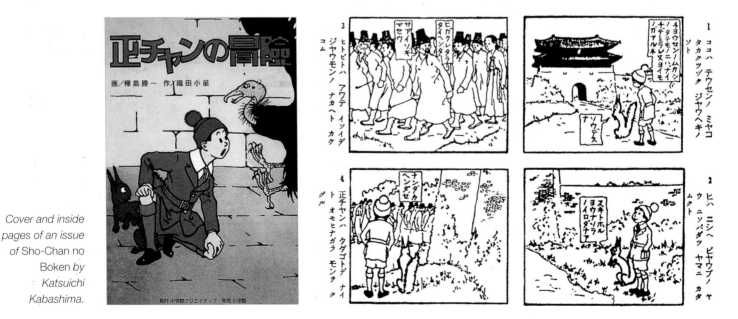

Cover and inside pages of an issue of Sho-Chan no Boken *by Katsuichi Kabashima.*

THE THIRTIES

During the 1930s, the first specific genres made their appearance: *kinshin manga* and *katey manga*, of familiar or everyday life flavor, and *kodomo manga,* for children. *Spido Taro*, published in the magazine *Yomiuri Sunday Manga*, also first appeared and became one of the most revolutionary series for the design of manga. The latter adopted rhythm and techniques from the United States through the drawings of Sako Shishido, who had studied art in the United States. The scriptwriter Ichiro Suzuki and the artist Takeo Nagamatsu created *Ogon Bat* in 1930, the first superhero in the history of comics, which became one of the most lasting and popular of Japan.

Ogon Bat *(1930), first superhero in the history of comics. It began as a* kamishibai *(Japanese storytelling cards), then it turned into a manga series, and in the 1960s was one of the most popular anime in Europe and Japan.*

Spido Taro, *by Sako Shishido.*

One of the most outstanding characters in 1931 was Norakuro, *done by Suiho Tagawa for the magazine* Shonen Club.

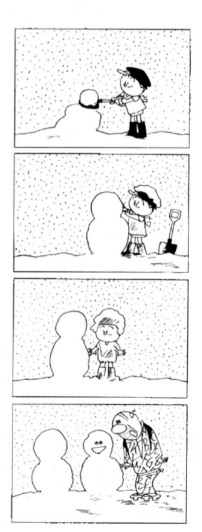

A new genre, yon-koma *or the daily strips, that soon became very successful made its appearance in the daily press and in children's magazines. An example of it was* Fuku-Chan, *created by Ryuichi Yokoyama in 1936, which narrated funny situations with a child as the main protagonist. The success of this comic strip character spanned three decades.*

Manga During
and After World War II

The onset of World War II brought about many changes in the production of manga. The first was a considerable reduction in its production due to censorship, which also resulted in a change of direction in terms of content. Most manga dealt with subjects related to war; *Norakuro*, for example, lost its humorous tone during the war and became a series of bellicose narratives. Some new characters also surfaced, such as *Hatanosuke Hinomaru*, a story about samurais who fulfilled all of the virtues of the official militaristic policies: nationalism, loyalty, and a sense of duty.

During these war years, the few genre that kept the manga alive in Japan were

- *Kamishibai,* or "paper theater," were stories that were shown cartoon by cartoon to a public audience in the town square or at a park, the same way that western medieval troubadours did in their time.

- *Kashibon*, or "lease manga," were distributed through libraries. They established a system of loans through centers scattered across the entire country and created their own manga in the form of magazines or 150-page volumes.

- *Akabon*, or "red books," originated in the city of Osaka. They received that name because they were printed in black and white and had bright red covers. They consisted of about 200 pages printed on low-quality paper to keep their cost down. The collaborating artists were paid very small salaries, but in exchange they enjoyed great creative freedom.

Sazae-san (1946),
work by Machiko Hasegawa. © Machiko Hasegawa.

Sazae-san was one of the most beloved characters of the Japanese public. Its strips and movies became tremendously popular.
© Machiko Hasegawa.

MACHIKO HASEGAWA

In postwar Japan several important events related to the world of manga took place. In 1946 Machiko Hasegawa became the first female manga author. She created the comic strip *Sazae-san*, a series with a regional flavor, that first made its appearance in the evening paper *Fukunichi*. From 1949 to 1974, when its author retired, *Sazae-san* was published in the national journal *Asahi Shimbo*. *Sazae-san* narrated the daily life of a middle-class Japanese family through the 68 volumes included in the work. In 1948 the first movie adaptation was made, which was followed by twelve more, the last one in 1975.

Still shot from one of the movie adaptations of Machiko Hasegawa's work.

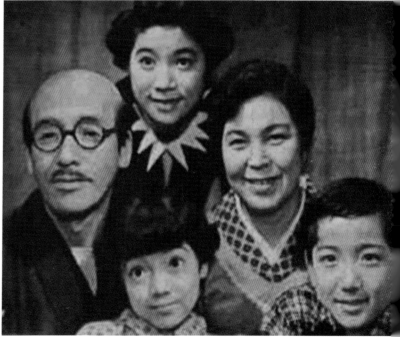

OSAMU TEZUKA (1928-1989)

Tezuka was the great discovery of the postwar era. He was considered unanimously as the *"Manga no Kamisama"* or literally speaking the "god of manga." Tezuka made his debut in 1946, but the first long piece that catapulted him to fame in 1947 was *Shintaka Rajima*. More than 300,000 copies were sold of this 200-page work. The rhythm of his stories showed a strong cinematographic style, which in the years following the war completely changed the concept of manga for children. For those who grew up with his adventures, Tezuka is a national hero.

He started drawing at a very early age inspired by the drawings of Walt Disney and Max Fleischer. This influence can be seen in his characters, who have the characteristic big eyes, a detail of the style that was later imitated by other creators of manga. This is the reason why the "big eyes with shiny pupils" is one of the most representative hallmarks of manga.

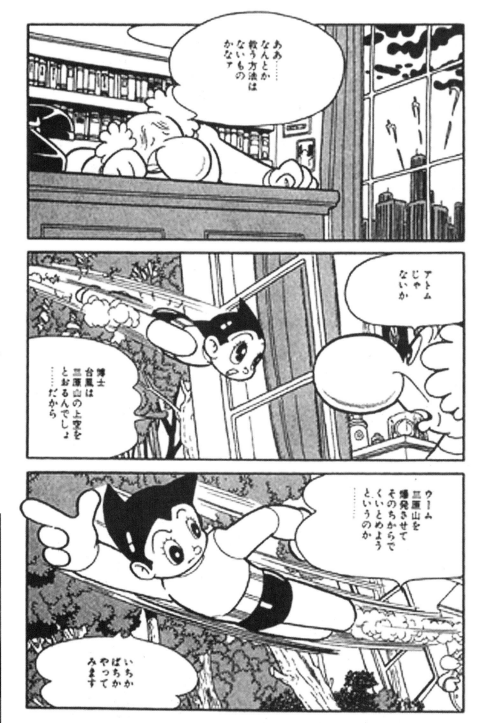

Images of Tetsuwan Atom (Astroboy). © *Tezuka Productions.*

First long work of Shintaka Rajima, *from 1947 by Tezuka.* © *Tezuka Productions.*

Tezuka not only stood out as a creator of manga, but he also did it by becoming one of the precursors of the anime industry of Japan. His work is as extensive and prolific in anime as it is in manga, with a format for television series from his own production company. In 1947, Tezuka collaborated on the creation of the magazine *Manga Shonen*, the first monthly publication completely devoted to manga. Many of the artists associated with this project soon became very famous. Tezuka created his character *Tetsuwam Atom (Astroboy)* with a first appearance in the magazine in 1951, and whose adventures ran until 1968. *Astroboy* was very popular and became an emblematic comic. The studio Mushi Productions, founded by Tezuka, produced an anime series of about 193 episodes with the character in addition to a full-length film that appeared in 1964.

In 1953, Osamu Tezuka moved from his native Osaka to Tokyo, and he settled down in an apartment in the Tokiwaso building. Other manga artists would later move into this building, which in time turned into a legendary and mythical place, to the point that in 1996 a movie, originally titled *Tokiwaso no Seishun* and directed by Ichikawa Jun, was made about it.

The importance of Osamu Tezuka was due in large part to his great productive ability and to the influence that he had on many other manga authors, who like him, introduced in their narratives a rhythm that was almost cinematographic.

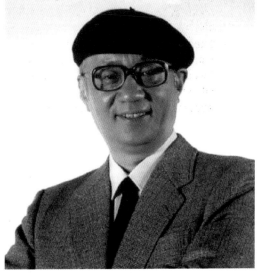

Osamu Tezuka.

Tetsuwan Atom (Astroboy), first appeared in 1951. He continues to be a popular character internationally.
© *Tezuka Productions.*

The Postwar Boom

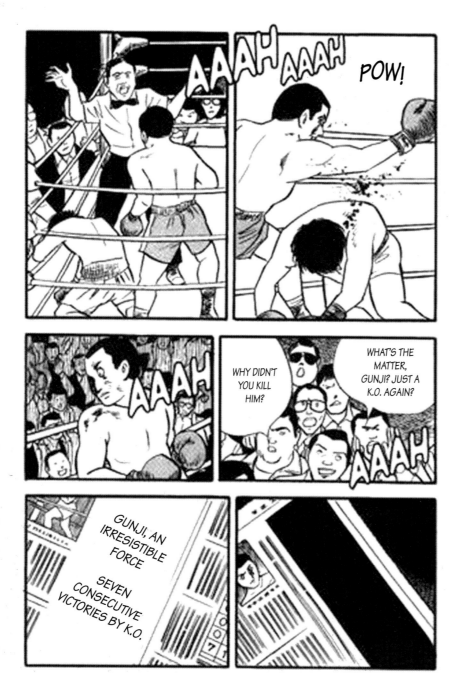

at the end of the 1950s, economic growth gave rise to the demand for more manga, creating the boom of weekly publications. The term *gekiga* (dramatic images), coined by Yoshihiro Tatsumi in 1956, would open up manga to a new genre directed to adult audiences. Its content was violent, pornographic, and dark. In 1959, the book publisher Kodansha published the first issue of *Shonen Magazine*, followed by other magazines from the other major publishers: Shueisha, Shogakukan, and Futabasha. All this resulted in the elimination of magazines that were strictly for young audiences, originated during the prewar years, and gave way to the multiplicity of contents, themes, and subjects that we are familiar with today. In the 1960s the *gekiga* reached their pinnacle, and many manga magazines devoted only to adult audiences made their appearance. In 1964 the artist Sampei Shirato published the magazine *Garo Manga*, the only one in the history of manga with a clearly underground content. It enjoyed more that 40 years of uninterrupted publication.

Passing Bell, one of the brief works by Yoshihiro Tatsumi, the creator of the term gekiga, *which started the creation of manga for adults.*
© *Yoshihiro Tatsumi.*

The production of manga continued to grow, now with million-dollar salaries, which made their authors into indisputable stars. The sales increased very rapidly, making manga the most important audiovisual form of communication in Japan.

Paradoxically, while in Europe and America, the expansion of television began to produce a big decline in comic production, in Japan the popularity of television accelerated production spectacularly, as animation provided for the adaptation of manga to the popular series of anime.

A number of artists such as Go Nagai and his work *Harenchi Gakuten (School Without Shame)* reintroduced manga for youngsters in the magazine *Shonen Jump*, which was launched by the publisher Shueisha in the year 1968.

The "crazy" character of the work by Go Nagai created great controversy among parents and educators, to the point that his stories were supressed. But the taboos were already broken, and the door was wide open for new, daring attempts in the publications for "all audiences."

Kamuiden, *work by Sampei Shirato from 1964.* © Akame Productions/Sampei Shirato.

Harenchi Gakuten, *from 1968, by the author Go Nagai, who is also the creator of the popular* Mazinger Z. © Go Nagai.

Manga from the End
of the 20th Century to the Present

In the 1970s the mangas for adults were consolidated. The magazine *Garo Manga* reached a publication run of 70,000 copies and a new "degenerate art," the *ero-gekiga*, appeared in such magazines as *Manga Erotopia* (1973), *Manga Erogenika* (1975), and *Manga Alice* (1977), where the only editorial premise was explicit sex. With the banning of the representation of genitals by Japanese censorship laws, the genre was pushed toward areas that were permitted: extreme violence and the proliferation of paraphilia.

Toward the end of the 1970s and the beginning of the following decade, new magazines intended for a more mature audience made their appearance. Some of the more representative ones are *June* (1978), the first one with

homosexual content, mostly for women with love stories between men, *Young Jump* (Shueisha, 1979), *Big Comic Spirits* (Shogakukan, 1980), and *Morning* (Kodansha, 1982). During the same period, the first manga for adult women also made their appearance *(Lady's comics)*, as well as the first ones of an informative nature, the *Joho Manga*. All these magazines were supported by artists who came from the *dojinshi* (fanzines) and who brought new ideas and currents to the publications. However, they had to moderate their erotic content to be able to gain access to the large commercial publishing houses.

Cover of the magazine Super Jump, *the "older sister" to the magazine* Young Jump, *from 1979, both published by Shueisha.* © Shueisha, Inc.

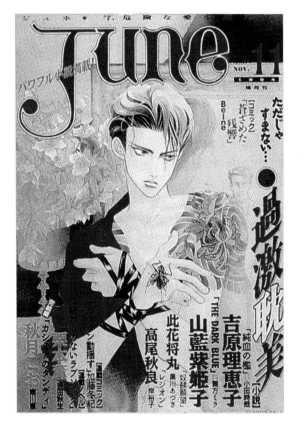

Cover of June, *a magazine that surfaced in 1978 and was the first one devoted to the yaoi genre.* © San Shuppan.

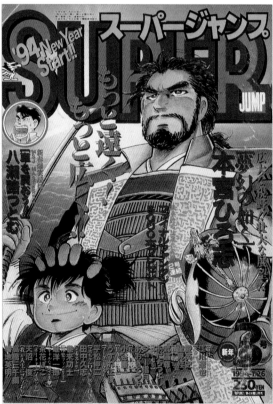

In the 1960s Osamu Tezuka sold the broadcasting rights of his first *Astroboy* series to the American network NBC, which enjoyed an incredible success among young audiences. But it was not until the 1980s and 1990s that manga came out of Japan and began to be published in the United States and Europe thanks to the success of *Akira* and to series like *Roboteck* and *Gundman*.

Without a doubt, it was a time of great advances, in which the styles diversified to the maximum and where *Shojo Manga* reached its highest point of development. Between 1980 and 1990 manga expanded outside of Japan and created a true social phenomenon in many Western cultures. *Akira* by Katsuhiro Otomo, and mainly its debut in anime, opened the doors wide to the Western world, since until then only a few series of anime could be seen on European and North American televisions. From that moment on it was not unusual to find manga series in bookstores and newstands.

From the last two decades of the 20th century until the beginning of the current one, new authors and titles have been appearing in magazines constantly. *Shonen Jump*, for example, published *Dr. Slump* by Akira Toriyama between 1980 and 1984, *Captain Tsubasa* by Yoichi Takahashi between 1981 and 1988, *Dragon Ball* by Akira Toriyama between 1984 and 1995, *Rurouni Kenshin* by Nabuhiro Watsuki between 1994 and 1999, and *Naruto* by Masashi Kishimoto beginning in 1999. Since 1999 the series *Love Hina* by Ken Akamatsu has been published in *Shonen Magazine*, along with many more works that would be impossible to cover in this brief introduction.

Cover of Big Comic Spirits, a magazine that came out in 1980, published by Shogakukan. © Shogakukan.

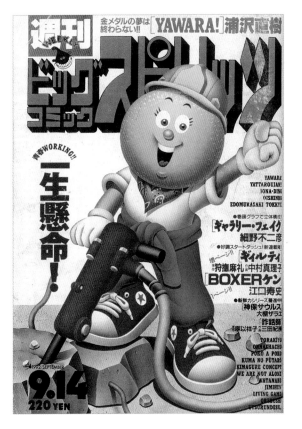

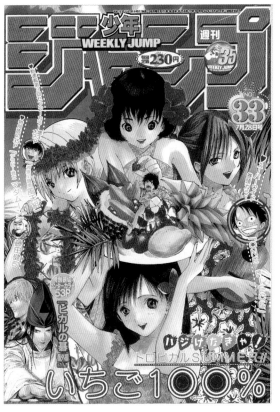

The magazine Shonen Jump, *published by Shueisha, with approximately 500 pages weekly, was the most widely sold at the end of the 20th century, with a publishing run of six million copies weekly. © Shueisha, Inc.*

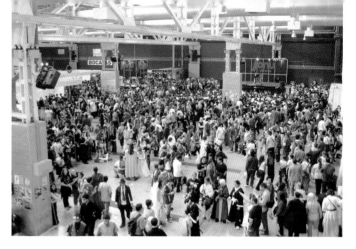

manga is without a doubt a phenomenon of the masses in Japan. Until the end of the 20th century, almost 40% of all books and magazines published belonged to this genre. There are publications for every sex, age, work situation, etc. In the book *Dreamland Manga*, Frederik Schodt places the reading of manga at fifteen publications per Japanese per year.

Many Western followers attend the international manga fairs that take place all across Europe and America. The photograph shows the Salon of Manga in Barcelona, which takes place in Hospitalet and is one of the most important after the fairs in Japan.

The Importance of Manga
in Japan

HOW MANGA IS PUBLISHED

Most of the manga magazines are published weekly or monthly. Their runs exceed one million issues weekly, and they have between 200 and 900 pages. They contain different series of approximately 20 pages each, and multiple stories of the *yon-koma* type (strips of four panels).

They are printed on low-quality paper to offer them at low prices; they are bulky (they look like phone books) and are rarely collected. In general, they are thrown away after they are read, either in their entirety or after saving only the favorite cartoons that are of interest to the reader. In addition to these, other publications called *tankobon*, are printed on higher quality paper so they can be collected by the readers who are attracted by a specific story in the magazine. The *tankobon* include the stories published in the magazines. Each book has 200 pages, and each series takes up a specific number of books.

Manga, a pastime available to anyone and enjoyable for all types of audiences

The merchandise derived from manga and anime series is one of the main sources of income for the manga industry.

Right. The large quantities of manga published in the Western world is evidence of the interest that this medium draws outside of Japan.

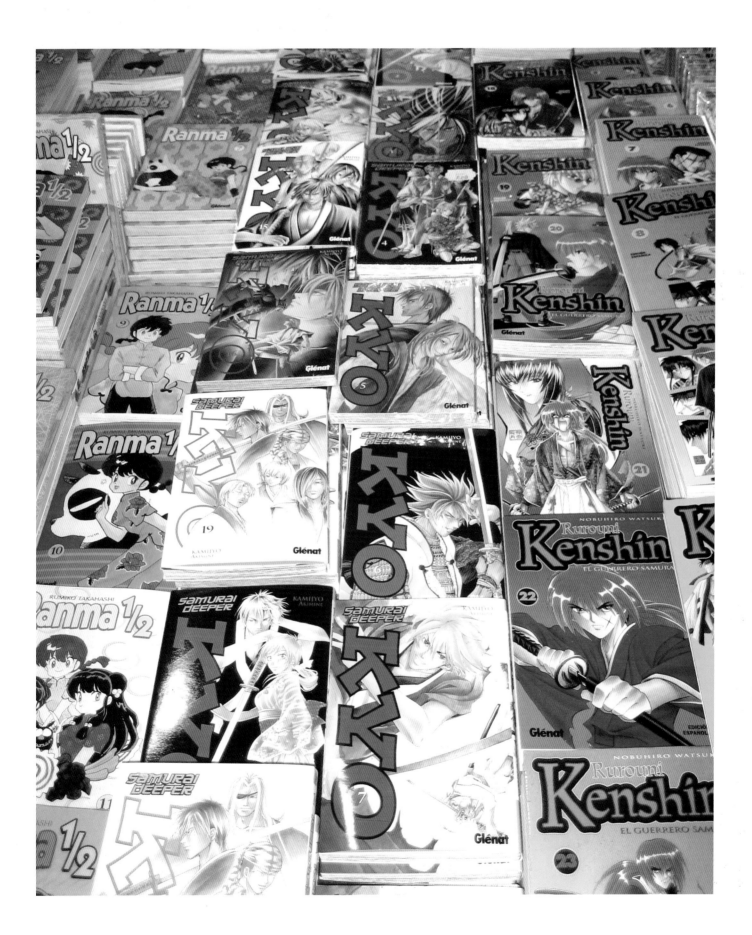

The Styles

DAISUKE TERRAZAWA.
*CELL FROM THE ANIME VERSION OF THE
MISTER AJIKKO SERIES.*

of Manga.

In Japan there is a style of manga

for every imaginable taste.

We could make a preliminary classification
by groups of readers according to sex, age, personal preferences, etc., but it would only represent a miniscule part of the very vast world of Japanese cartoons, where each publication tries to include the greatest variety of styles in its pages. One would think that the world of manga in Japan is very chaotic, but nothing is further from the truth. The Japanese aficionados of manga know exactly where and how to find what they are looking for. This however is more difficult in Western cultures since only a very small part of all the material that is produced arrives here. So, there are mangas for children, for young people (for boys and girls), and mangas for adults in all varieties and possibilities, including specialized mangas classified by trade, profession, and even by hobby.

The Main
Types

It is very difficult to define any artistic expression by genre since concepts, when they are so similar, end up being mixed together and can be confusing. A genre is a collection of elements or characters that share a series of common attributes. In movies, comics, novels, etc., the genre includes the group of works that represent similar characteristics to achieve a common goal. That is, when we talk about comedy, drama, romance, adventures, etc., genre is limited to the content. Also included in the term "genre" are the stories that share a background, or the space and environment of the style: police and period stories, science fiction, fantasy, scary stories, etc. This second group can deal with any of the concepts of the first classification, for example, a movie, a comic, a novel, or a police story manga can be at the same time comedy, drama, romance, or adventure. Therefore, we divide genre into two groups:

- Genre in terms of its content: comedy, drama, tragedy, and so on.
- Genre in terms of the background: police story, period, science fiction, among others.

To give the reader an idea of the different types of manga available on the market and to be able to identify them quickly, we narrow them down to four main categories based on sex and age: *shonen, shojo, seinen,* and *kodomo*.

The market for manga is very diverse. There is a genre or a subgenre that is suitable for the most demanding reader

SHONEN

The word *shonen* means "boy." It encompasses all the stories for boys that could be appealing to an adolescent male audience.

We cannot, therefore, say that *shonen* is a genre per se, because this classification includes very different authors that express themselves in many styles and the contents of the stories can be represented in very different genres.

A *shonen* manga includes the following:

- Its protagonists are adolescent boys, archetypical and with a generic psychology with which the reader is able to identify immediately.
- The stories tend to be focused on personal achievement. After overcoming obstacles a specific objective is achieved.
- Its narrative is dynamic and includes many action moments.

The Dragon Ball *series, whose protagonist is Son Goku, is perhaps one the most representative mangas of the* shonen *genre to arrive in the Western world. Its author is Akira Toriyama, and it was published in the magazine* Shonen Jump *in 1985. The complete works include 42 volumes. © Shueisha, Inc./Akira Toriyama.*

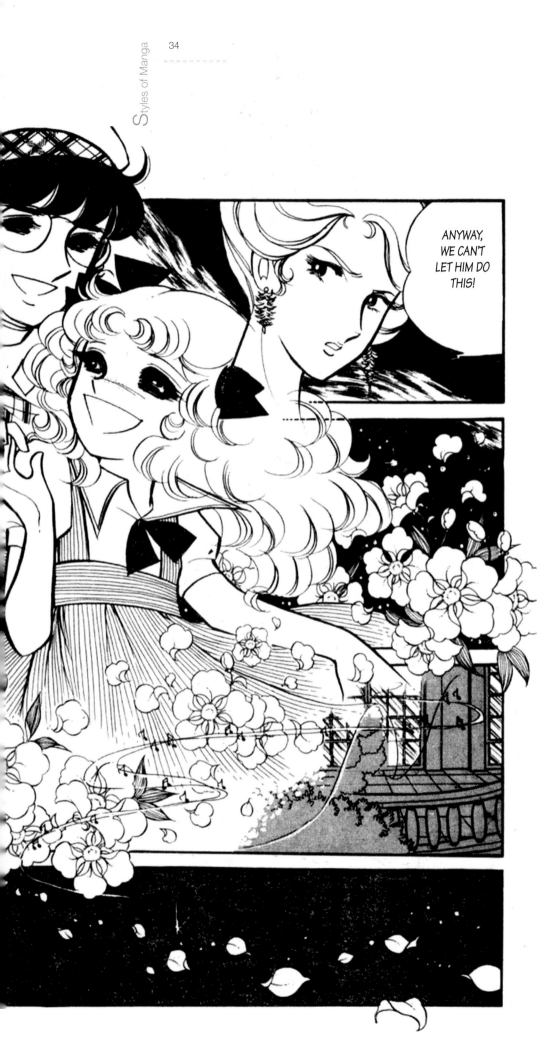

ANYWAY, WE CAN'T LET HIM DO THIS!

SHOJO

Shojo means "girl." The *shojo* manga can include stories for any age, whether they are young girls or adolescents. In the beginning, it was men who drew and created *shojo*. Beginning with the 1970s, women decided to play an active role in the world of manga, and through *shojo* they were able to choose the subjects that they knew were more relevant for their audiences, which consisted mainly of women readers. It is important to mention that while *shonen* puts more emphasis on the action, *shojo* concentrates on the feelings of the protagonists.

Its characteristics are:

- The protagonists are girls, adolescent or adult, depending on the audience for which the story is intended.
- The genres are varied, but romantic content is the most common.
- Its dialog is slow because it thrives on the feelings and the thoughts of the characters.

Candy, Candy, *with script by Kyoto Mizuki and drawings by Yumiko Igarashi, is a* shojo *manga with a large dose of melodrama.* © Kodansha/Kyoko Mizuki and Yumiko Igarashi.

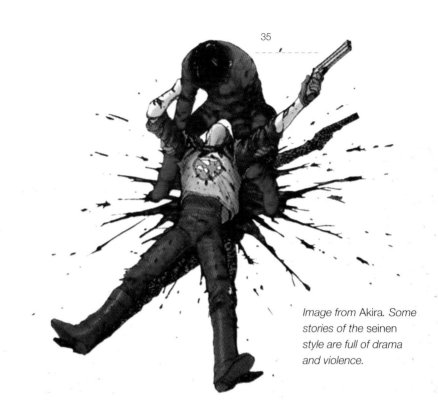

SEINEN

Seinen means "of age" or "adult." This manga is suitable for audience ages 18 and older, and it attracts young people who, moving away from *shonen*, are interested in dialogs that are more involved and developed rather than just simple action.

Seinen made its appearance in the 1960s. It spread quickly to numerous magazines and is read mainly by young people between the ages of 18 and 25; although it also has a large following among people 30 and 40 years old. In the beginning it was intended for male audiences, but soon female counterparts called *Josei* manga and *Lady's comic* made their appearance, intended for women 20 years of age and older.

In a *seinen* manga we find the following:

- The protagonists are adults involved in police suspense, *yakuzas* (Japanese mafia), businessmen, company men, etc.
- The genres as well as graphic styles are very diverse, despite the predominance of a realistic drawing style.
- The dialog tends to be very direct and parallel to the movie dialog. Humor takes a back seat to give way to more involved content, and sometimes to eroticism and violence.

Image from Akira. *Some stories of the* seinen *style are full of drama and violence.*

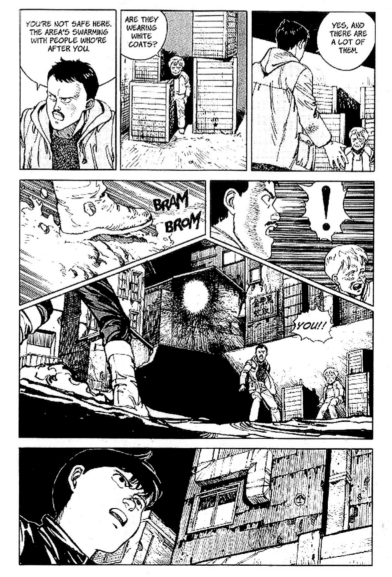

Akira, the popular work by Katsuhiro Otomo. The stories were published in 1982 by Young Magazine. *This work consists of 6 volumes.*
© Kodansha/Katsuhiro Otomo.

KODOMO

The word *kodomo* means "child" and comprises all the stories for the youngest children. The most common graphic style of *kodomo* is humor, and its content is casual and familiar. It is presented in several formats, from a page length to a strip of 4 cartoons known as *yon-koma*.

The main characteristics of a *kodomo* manga are:

- The protagonists are boys and girls (often accompanied by pets) with which the young audiences can identify easily.
- The genre, contents, and graphic styles vary, but the humorous drawing is the most prevalent.
- The dialog is usually dynamic and presents a simple and simplistic plot that allows for quick identification with the various situations.

Stories of Doraemon. *This manga made its appearance in the magazine* Shonen Jump *in 1984, and it has also had great success in Western cultures thanks to the anime series. In these examples the* kanji *characters are simplified to make reading easier for Japanese children who, due to their young age, cannot read yet.* © Fujio-Fujiko.

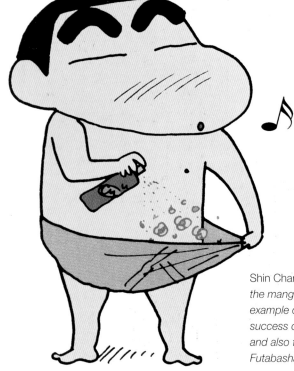

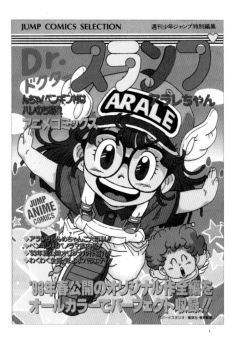

Cover of an Arale *magazine by Akira Toriyama. A popular manga in the Western world, it falls somewhere between the* kodomo *and* shonen *styles. The drawing style is closer to the later genre, but not the dialog, which has a fantastic and humorous plot at the same time.* © Shueisha, Inc./Akira Toriyama.

Shin Chan *is the shameless protagonist of the manga series by the same name. An example of* kodomo *that has had great success outside of Japan through anime and also through magazines.* © Futabasha/Yoshihito Usui.

"Touya Kinomoto." A bishonen *character from the* Sakura *series created by the Clamp studio and published in the magazine* Shojo Manga Nakayoshi. © Kodansha/CLAMP.

"Asuka Langley." A bishojo *character and one of the main protagonists of the* Evangelion *series by Yoshiyuki Sadamoto. It was created in 1995 for the publication* Shonen Ace. © Kadokawa/Yoshiyuki Sadamoto.

The great number of genres and subgenres that exist in manga make it possible for the most demanding reader to find the story with which he or she can best identify.

OTHER GENRES

In addition to this very general first classification, there are other genres, which are in turn divided into many subgenres and branches. These, no matter how interesting, particular, or strange they may appear to Western audiences, in Japan have gained many followers that eagerly consume their stories in weekly and monthly magazines. Due to their adult content, these magazines are only suitable for adults and can be found in very specific and specialized publications.

Bishonen, or "handsome boys," manga is found in the genre of *shojo* stories which include very attractive male characters with delicate features that are appealing to female readers.

Bishojo, or "pretty girls," manga is similar to *bishonen* but include pretty female characters with delicate figures in *shojo* stories mainly, but also in *shonen* stories.

Captain Tsubasa, by Yoichi Takahashi. It is a shonen of the spokon manga genre. © Yoichi Takahashi/Tsuchida Production.

Spokon, or "sporty spirit," manga protagonists have to take a long and hard path to become indisputable stars of the sports they practice and to which they devote themselves with dedication and sacrifice. It constitutes a subgenre of *shonen*, which has become very important because in Japan every sport has its own series.

Gakuen, or "high school," manga narrates the stories of children and adolescents that take place in a high school or in an educational institution.

Jidaimono manga is historic in nature and narrates the epic episodes of Japan, starring ninjas, samurais, or other invincible warriors.

Sentai manga narrates stories of heroes, soldiers, and warriors with mythical powers.

Joho manga is an "informative manga" that includes teaching content for the youngest readers or biographies of important characters from Japan, such as businessmen, executives, etc. Or they can be manuals on how to become efficient businessmen or teaching texts from business courses that have been turned into manga to be more appealing and entertaining.

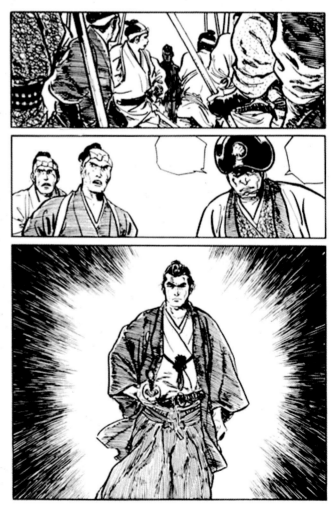

The Lonely Wolf and His Pup, by Kazuo Koike and Goseki Kojima. It is a seinen manga of the jidaimono genre. It takes place in the Edo period; its protagonist is a ronin, an able wandering samurai in search of vengeance. © Futabasha/Kazuo Koike and Goseki Kojima.

Mahokka, or "magical girls," manga narrates stories of girls who have magic powers and who fight against evil with the power of love.

Cyberpunk manga is set in the future and includes science fiction, technology, and cyborgs. Along these lines we also find **mecha** manga in which there are many robots.

Ronin manga is an interesting branch of the *seinen* genre, where the protagonist is usually embodied by a samurai who wanders aimlessly and without a master in search of occasional work as a paid thug or as a member of some *yakuzas* gang.

Josei manga is a genre for women 20 years of age and older.

Lady comic is a specialized genre for housewives, office workers, and workers in general. It contains large doses of romantic material, clandestine dates, and meetings between lovers.

Redikomi is a genre for married women, with content about life as a couple, children, etc. It also covers intrigue and suspense stories.

The limited nature of certain genres, subgenres, and branches are confusing and sometimes difficult for the Western follower to find, especially when only a very small part of the material that is published in Japan is available and some genres are excluded entirely.

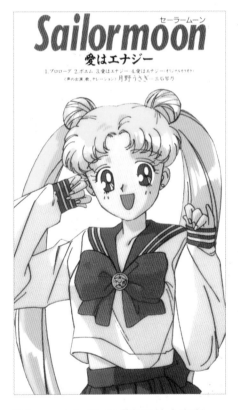

Sailormoon, by Naoko Takeuchi. A shojo manga where the heroine receives magic powers and becomes a "magical girl."
© Kodansha/Naoko Takeuchi.

Ghost in the Shell, by Masamune Shirow. Seinen cyberpunk with philosophical aspirations.
© Kodansha,Ltd./Masamune Shirow.

Gag manga encompasses all the comedy manga, mostly for adults, where we find everything from chuckles to the most absurd humor. A subgenre is **unku** manga, literally "shit manga," which deals with incredibly scatological stories without scruples.

Ecchi is a manga with very soft erotic content, which can be found in *shonen*. There is no explicit sex, but there are naked and seminaked characters. It can be suitable for underage people.

Hentai, or "perverted," manga can include any erotic manga with soft sexual content (*ecchi* can be part of *hentai*) or pornography with explicit and hardcore sex. As one can see, there are many subgenres, which may belong to *hentai*, for example:

Shonen-ai manga is based on homosexual relations between adolescent men in *shonen* stories. However, the sexual content is rarely explicit, and it does not go beyond a kiss between the male protagonists.

Love Hina, by Ken Akamatsu. A shonen *that interestingly enough has captured more female than male readers. A gakuen genre in its pure form, it is also a soft* hentai, *that is, an* ecchi. © Kodansha/Ken Akamatso.

Gravitation, by Maki Murakami. A shonen manga, that is further categorized as shonen-ai. *It has to do with a musician who falls in love with a talented writer. It is a very fun manga for all audiences.* © Tokyopop, Inc.

When the protagonists are girls, it is called **shojo-ai**.

Yuri manga is homosexual relations between girls, also with less sex-explicit content found in some of the *shojo* stories.

Shota-kon shows sexual relations between children or between children and adults: **loli-kon**, with relations between girls or between girls and adults, and **yaoi** with adolescent male characters that maintain very explicit homosexual relations. This genre is also called **anguish** when its content has an added tragic component. Some of the characters in the story die and the story can have a sad ending.

Gore manga, or bloody and gory manga, is generally censured in many countries because it contains truly extreme scenes.

The main manga genres—*shonen*, *shojo*, *seinen*, and *kodomo*—are already well known in the Western world, but the suggestive images of *hentai* are also appealing to Western audiences.

Mazinger Z, by Go Nagai. Although it was not the first manga with giant mechas robots, it did make this genre and manga in general popular in many Western countries.
© Shueisha, Inc./ Go Nagai.

Sensual illustration by the master of eroticism and of hentai U-Jin.

The Mate-rials

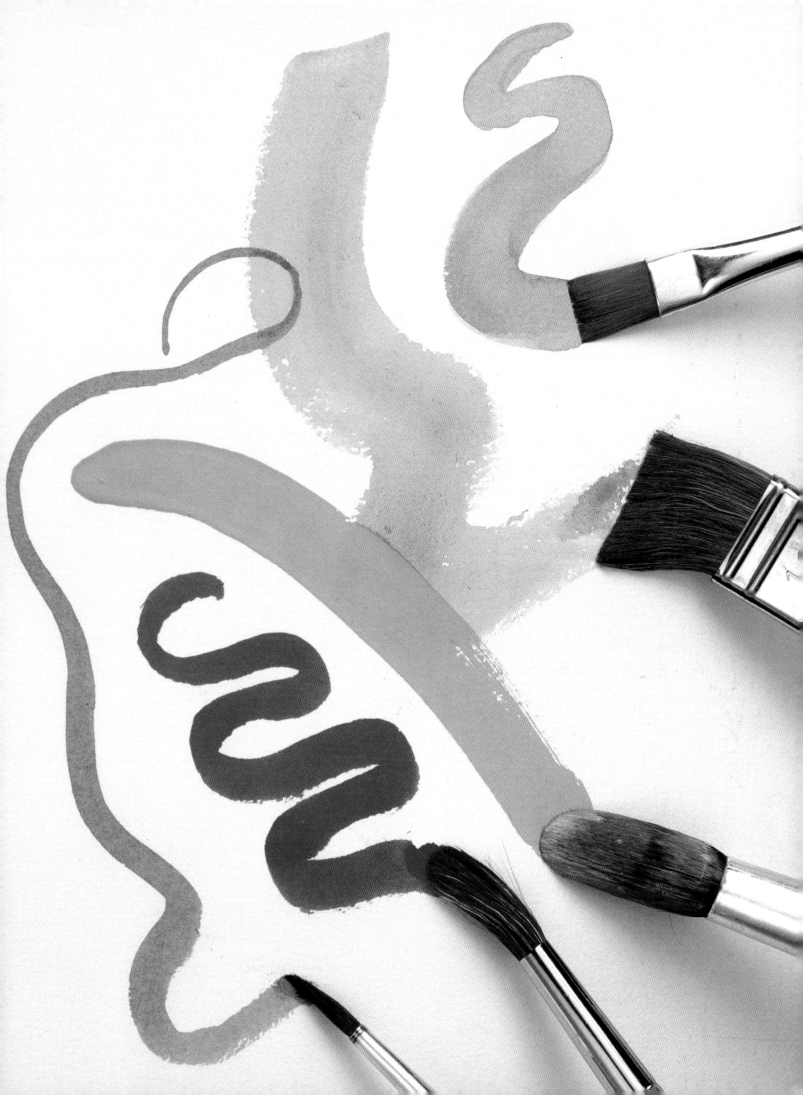

Regular Pencils
and Mechanical Pencils

any material or technique can be used to create manga or an important part of it. In essence, all the materials that are used for the illustration and creation of comics in the Western world qualify. The manga artists must be aware of the quality and possibilities of the different materials, as well as the different techniques, since even though they may work in teams, they will have to supervise the work produced by the assistants.

Artists use from traditional wood pencils to mechanical ones with interchangeable leads of different thickness, hardness, and colors. The choice depends on the model that the *mangaka* (manga artist) feels more comfortable using. However, it is interesting to be aware of the particular options of the different pencils.

Mechanical pencils with interchangeable graphite leads. There are graphite tips of different densities and colors. Some artists prefer them for their comfort.

Conventional wood pencils to make line drawings. The density of the lead is marked on each one.

THE BLUE PENCIL

This is used for sketching. The forms are later drawn with black pencil or directly with ink. The advantage of the blue pencil is that it does not show in black and white copies and thus eliminates having to erase the pencil lines after the ink is applied.

THE HARD PENCIL

This is used for drawing after the sketch. The hardness of the lead ranges from "H" to "8H." It produces a very thin line, ideal for backgrounds and very suitable for drawing perspectives and technical drawing in general. It is important to control the pressure applied on the paper because it can scratch it, and the marks may stay after erasing.

THE SOFT PENCIL

This is also used to draw after the sketch. The varieties range from "B" to "8B." It is usually the pencil favored by most artists since its lead makes is able to create many nuances. The tip can be shaped to draw lines of different thicknesses and to help create a feeling of depth. It is important not to brush the surface off with the hand because this lead can smear the drawing.

Sketching with blue pencil is always a choice, but many artists prefer to work directly with black pencil and then to erase it after the ink has been applied.

Sketch created with a blue pencil.

Example of a drawing made with a "2H" lead.

Example of a drawing made with a "2B" lead.

The top and bottom of this page show some of the papers normally used for manga work. Generally, these papers are very common.

Papers
Used Most Commonly

any type of paper can be used for drawing manga. Practice, experience, and trial and error reveal which papers are the best to use with a specific technique and style. Normally, the work is done 30% larger than the size of the finished job; this way the details can be worked better. The paper is selected based on the technique used to ink the page. Therefore, it is a good idea to keep the following criteria in mind.

MATTE PAPER
As long as it does not have too much texture, matte paper is always very practical for ink applied with a brush because its surface is porous and absorbs the ink very easily. Black looks very black, but the mistakes must be corrected with gouache-type white paint. Also, pencil lines leave marks after they are erased.

SATIN PAPER
This is ideal for work with nib pens, but brushes also work smoothly. The drawback is that the ink takes a long time to dry and dark black surfaces may look cracked or leave unwanted wash marks. Its most positive feature is that small mistakes can be removed by scraping the paper gently with a cutter or razor blade.

COMBINATION PAPER
This is perhaps the most suitable because it combines the advantages of both the matte and satin papers, and at the same time it minimizes the drawbacks of both. However, it all depends on the particular needs of the artist and the specific style that he or she wants to use.

Illustrated on the right is a special paper for drawing manga, Manga Manuscript Paper. It is used in Japan by some artists because it has blue guidelines that help layout the cartoons on the page and also shows the areas that will not be seen in the reproduction after the layout designer works with them.

Inking
Manga Drawings

This step can be done with more than one technique; the most important thing is to combine the different tools intelligently to achieve the desired results every time.

MARKERS AND FOUNTAIN PENS

There are a variety of these when it comes to thickness, tips, styles, etc. Some types have felt tips, and other, more specialized ones have brush tips.

They are available from very thin, for small details, to thick, for filling large areas of black.

There are also various rechargeable fountain pens, like the traditional Rotring brand, but from different makers and with different characteristics.

Markers are rarely used to ink a page of manga, but knowing how to use them can help achieve important parts of the job.

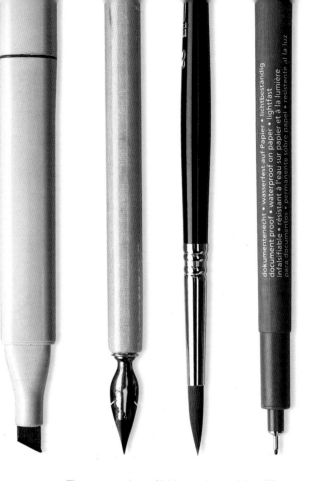

The great variety of inking tools provides different styles of finishes.

Felt-tip markers of different thicknesses for details and drawing in general.

Brush-tip markers are very practical because the tip does not need to be dipped in ink. Some are rechargeable and for the most part are very durable and produce good results.

INK PENS

There are a variety of models, and it is a matter of choosing the most appropriate one for the particular drawing. In Japan it is customary to draw manga with an ink pen, because it has the advantage of producing different lines depending on the pressure applied on the paper. The technique itself is not easy, as it requires practice, but the results are very pleasing.

BRUSHES

Brushes require special care because the bristles have to be kept in good working condition to be able to draw lines evenly. They have to be cleaned every time they are used and covered with a protective device, if possible. A brush that is not in good condition can ruin an inking job. The variety is extensive and includes synthetic and natural bristles, both suitable for drawing with ink. There are different tips—flat, round, filbert, etc.—and they are available in different thicknesses.

Of all the different existing varieties of pens, the ones most favored by mangakas are the Turnip-Nib, because they produce thin and even lines, which are ideal for drawing backgrounds. The Round-Nib is suitable for lines in general because its thickness can be controlled depending on the pressure applied.

Brushes of different shapes and thicknesses. From top to bottom: thin round, flat medium, filbert, and thick round.

When working with ink, it is important to keep the following materials handy: rags, blotting paper, a container with water to wash the inking tools and ensure that they are in optimum condition, and a piece of scrap paper of the same type as the one used for the work to test before applying the ink permanently in a particular area that may be challenging.

Several Examples
of Inking

below are some examples made with the different inking materials. The best approach is to practice with all of them, since you will probably find that each one of them is suitable for a particular technique.

MARKERS

This ink work was done with Staedtler brand markers. To create the various finishes we have used different thicknesses from 0.2 to 0.8. We have worked the details of the background with them and highlighted the elements on the foreground a little bit more. A marker is probably not the most common tool for manga, but it is very clean and reliable. It is the best technique for the inexperienced artist until he or she becomes familiar with the rest.

Inking done with markers and fountain pens.

BRUSHES

Brushes are commonly used for cartooning in the United States and Europe. They are not easy to work with and require expertise and a steady hand, but they are very versatile and can produce a great variety of interesting effects. The dark areas of the work can be done with ink and a thick brush, or with markers, which allow working at a faster pace.

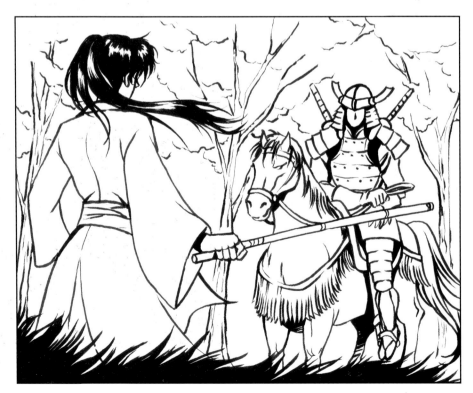

Inking done with a brush.

NIB PENS

Nib pens have to be selected carefully. There is such a variety on the market that it is important to try them out to see which ones are the most suitable to achieve the desired results. Below is a list of the most commonly used:

- **Turnip**: special for making even lines. They are easy to use but lack expression since they do not allow much variety in the thickness of the line.
- **G-Nib**: special for thick and even lines. When they are new they can also make thin lines.
- **Round**: perhaps the most suitable for any type of work. In essence, they are perfect for making very thin lines, but they are flexible and can produce lines of any thickness depending on the pressure applied.
- **"Spoon" shape**: similar to turnip. They produce consistent lines, but the lines cannot be changed.
- **Fountain pens**: not a nib pen, but similar. They are loaded with special ink cartridges.

HATCHING

Hatching allows the artists to create gray shading. There are several possibilities for this approach, from mechanical self-adhesive sheets of hatching to hatching done on a computer.

Many types of rulers can be used for inking, but French curves are especially helpful because they simplify the job when drawing large areas and when making lines that represent movement.

Inking applied with round and turnip pens.

Finishes done with mechanical crosshatching, which creates areas of gray shading easily and efficiently.

Applying Color
to Manga

Most of the manga published in Japan is in black and white. This is because the publications have hundreds of pages that are printed on cheap paper to keep their price very affordable. Seen this way, one could think that the artistic and creative potential of its creators is compromised. However, nothing is further from the truth, and although artists must stay close to the black and white guidelines in most cases, there are different opportunities where they can display their color abilities and other techniques. They are:

The covers. Manga magazines and collectible volumes tend to display very carefully composed covers. The author, who is usually in charge of its execution, works with the materials that he or she is most familiar with or that are most suitable for each case.

Inside pages. Some inside pages in magazines and collectible volumes are done in color. In these cases, the color not only breaks the monotony of black and white, but it also provides the reader with additional information about the story that he is reading.

Promotional material. There is no shortage of promotion for the manga series that are constantly being created in Japan. This competitiveness makes it critical for promotional materials to accentuate each product. These materials, posters, cards, magazine inserts, etc., are abundant and profusely colored.

An artist may choose to do a manga in color. Although still rare, there are mangas in full color, some of them clearly aimed at North American and European markets.

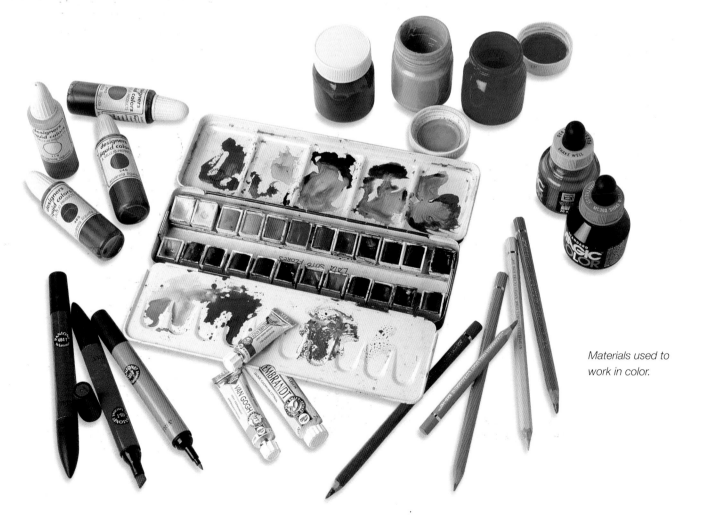

Materials used to work in color.

The same types of brushes are used for ink and for color. We recommend not using the same brush for coloring and for inking because it can have remnants of the previously used pigment.

GOUACHE AND ACRYLICS

Gouache paint is soluble in water and provides a matte finish. It has the advantage that, once dry, it can be diluted with water again, and this helps if touch-ups are needed. It is applied with lots of water, and its finish is very similar to watercolors.

Alternatively, acrylic paints provide a bright finish, and even though this paint is soluble in water, it cannot be diluted again after it dries. Therefore touching up is done by applying a new layer of color over the previous one.

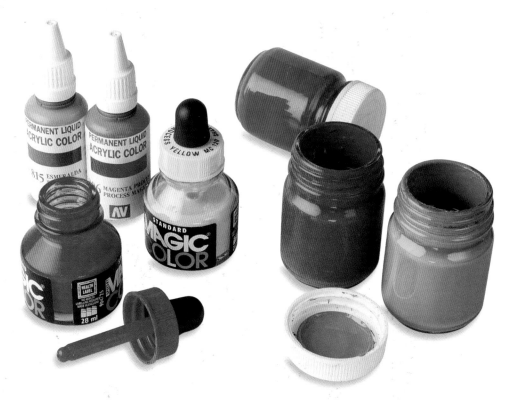

Jars of gouache and containers of acrylic paint.

WATERCOLORS AND DYES

The main difference between natural watercolors (in tube or cake form) and liquid watercolors (in glass or plastic jars) is the color brightness. Watercolors and dyes provide brighter and sharper colors. For a naturalistic job watercolors are probably the best; but for manga illustration, the brightness of the dyes is better. It is a matter of trying them out and choosing.

COLOR PENCILS

Color pencils can be water-soluble or non-soluble. They work best with non-satin matte paper, without any texture. Color pencils offer many possibilities because the work is done in layers from light to dark, and the intensity can be easily controlled. Also, the tip can be scraped to produce a powder, which can be spread with a blending stick, similar to pastels. Normally, the color is applied in the same direction, but the way the line is controlled can produce interesting textures. The main drawback is that the colors cannot be blended, and the only way to create different tones on an even surface is through hatching different color lines or by superimposing layers of color.

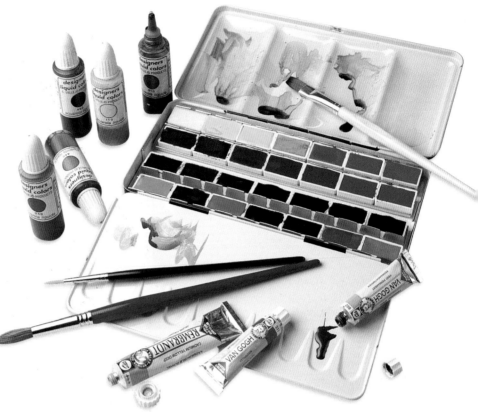

Different forms of watercolors and dyes: tube and cake forms for watercolors and plastic bottles for liquid watercolors or dyes.

A watercolor pencil and solid colored pencils and a blending stick for creating pastel-like effects.

MARKERS

The ones used in Japan are normally COPIC brand and come in a variety of tips: thick and flat, round, and brush tip. Markers produce brighter colors; this is good for the final presentation. Some brands allow the colors to be blended in different ways, for example, by using a liquid solvent, or a colorless marker that helps blend the outlines, or even by using specially made airbrushes for markers.

COMPUTERS

Computers can help simulate all the techniques covered so far and even create new ones. Their greatest advantage, besides speed, is that the artist can go back and correct mistakes or try new approaches over the same original, a task that is impossible with the traditional techniques.

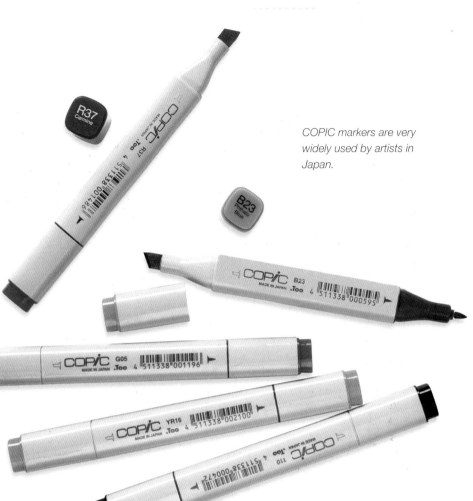

COPIC markers are very widely used by artists in Japan.

A perfect computer set-up to solve any artistic challenge requires greater investment, but it is more cost effective in the long run.

Some examples
of Color Finishes

The artist must test every coloring technique, whether to choose the one that provides the best results or to determine the best application process for the type of work being created.

GOUACHE
Since it is a water-based paint, the paper should be heavy or have a thin layer of coating. Gouache produces flat colors, but it is possible to create very artistic pieces with medium tones. It dries easily, colors are bright, finishes are even, and its opacity allows for painting light tones over dark papers. Creating gradations requires some practice, but they are possible and their finish is very pleasing.

WATERCOLORS
The paper should be similar to that used for gouache because watercolors are also a water-based paint. Watercolors are not opaque, and the base color of the paper always becomes the predominant one; therefore, to obtain different intensities we must work in layers from lighter to darker. Since watercolors can be mixed easily the range is endless. It is also simple to blend areas by working wet on wet; this is why it is easy to create gradations. Since the surface of the paper is white, the work has to be thought out carefully to preserve the white areas; however, light areas can be applied later using gouache.

Illustration created with watercolors.

Illustration created with liquid gouache.
The effect is similar to watercolors.

MARKERS

It is best to use smooth, matte paper as a base. A single color can be applied in layers to make it darker or brighter, and as mentioned before, some brands allow blending. Markers with a brush tip can be used to work on small details. The colors are very bright and produce beautiful finishes. We recommend having a wide range of colors available. It is necessary to exercise extreme care if you need to color large surfaces.

COMPUTERS

These can apply any technique, and some programs allow the creation of simulations of papers with different textures and weights. The savings on paint, brushes, and paper in the long run make up for the cost of buying good quality equipment to create digital finishes.

Illustration created on a computer. The effects are easier to produce than working by hand.

Illustration created with markers.

The Characteristic Narrative of Manga

"YOU MAY BE ABLE TO DRAW VERY WELL, BUT IF YOU DON'T KNOW HOW TO WRITE THE SCRIPT YOU WILL ALWAYS BE JUST AN ILLUSTRATOR. EVEN WITH THE HELP OF A SCRIPTWRITER, IF YOU CAN'T MAKE GOOD LAYOUTS (STAGING, COMPOSITION), YOU WILL NEVER BE A MANGA AUTHOR."

Rumiko Takahashi, author of Inuyasa.

The Structure

of the Narrative.

When reading a manga for the first time,

in addition to experiencing enjoyment, the reader's curiosity may be drawn to its many graphic aspects. However, the difference between manga and Western comics is its narrative structure. A manga tries to show movement in the story even though the work is created with static images. While this is also the intention of Western comics, in the latter, movement is shown by one or two panels that depict the action. In manga, the presentation of one specific action requires several pages and "contemplating" that action becomes the focus. To analyze the narrative of a manga successfully, the explanations will be approached according to two main concepts: **content** and **form**.

Content refers to the literary part, which together with the script, makes the reading of the manga interesting and appealing. It brings three concepts together: narrative rhythm; movement determined by the narrative; and drama, action, and suspense. Form deals with the graphic aspect and the "staging" of the story, and it plays an important role in the narrative. Its features are typology and expression, sound effects, composition, and narrative dramatization through the setting.

The Narrative Rhythm
of Manga

The content is the aspect of the manga that refers to the literary part, in other words, to those elements that together with the script will make the reading of the manga appealing and interesting.

The narrative rhythm consists of arranging the action from the cartoons in a way that makes the understanding of the story possible. The manga artist has to make the story flow naturally and in such a way that the action takes place in a span of time determined by the relationship established between the text and the drawing.

There are different rhythms in manga depending on the genre and style used. The rhythm of a *shonen* manga, full of action, will not be the same as that of a *shojo* manga, where the emotions of the characters take center stage.

In this shonen *page, an action scene is developed in such a way that each panel tells part of the story. This favors a quick reading rhythm due to the composition of the panels and the structure of the page.*

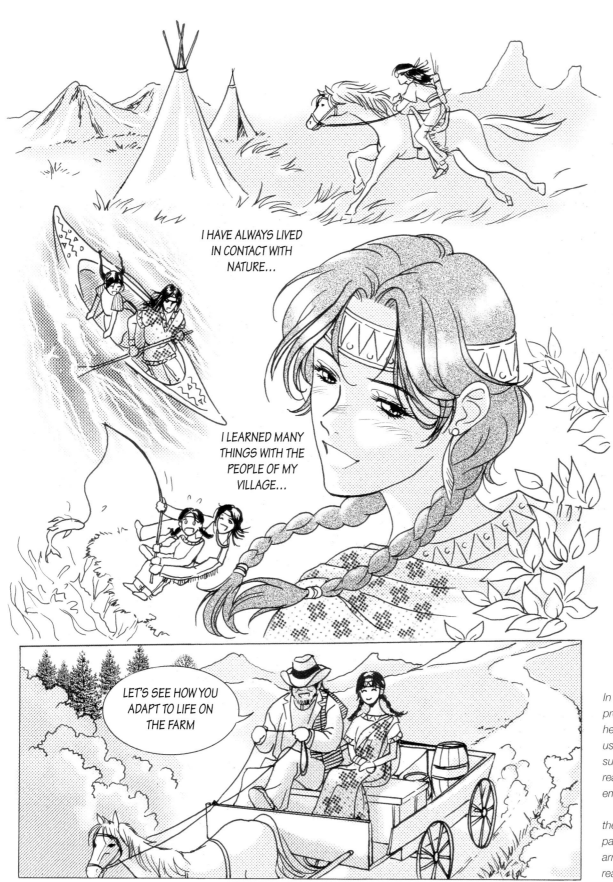

I HAVE ALWAYS LIVED IN CONTACT WITH NATURE...

I LEARNED MANY THINGS WITH THE PEOPLE OF MY VILLAGE...

LET'S SEE HOW YOU ADAPT TO LIFE ON THE FARM

A manga page can be a succession of panels in which the artist simply tells a story, or else a group of images that provokes a series of feelings.

In this shojo page, the protagonist takes us through her memories and entertains us with subtle details of the surroundings, which the reader perceives as brief emotions.

The layout of the page, the composition of the panels, and the overall arrangement favor a slow reading rhythm.

Movement Determined
by the Narrative

for the story to keep the reader interested, there are two basic factors that the artist must keep in mind from the beginning of the script: movement and action. It is very important to move the characters, to make them go from one place to another. A manga is not a dialog between two characters placed in front of each other in a specific place, without moving; the final result cannot be a static dialog. The situations cannot always be approached from the same point of view either; you must change the setting to present the characters at half body, full body, or with their faces at close-up angles, seen from above with sky views, from below, or seen with a view of the horizon. All of this can be used to "move" the action, and at the same time, each change, each "movement" gives the reader new information with respect to the details of the story.

CHANGING THE SETTING
In the following example we move the narrative by moving the setting. The first drawing shows a medium view of two characters talking. In the second one we break the monotony with a close-up of one of the characters. This way we prevent the amount of dialog from becoming boring by spreading it into two drawings and emphasizing the talking character.

Change of setting.

EXAMPLE OF FACE TO FACE

The setup is similar to the previous one, a dialog between two characters. In the first drawing the character is speaking with her back to the reader, and we can see the reaction of the listener. In the second drawing we can see the speaking character by reversing the setting. This approach helps us keep the action in the narrative while showing the reader information about the story through the reaction of the characters.

CHANGE OF LOCATION

The idea is to move the narrative forward by changing the location. So, in the example below, the first drawing shows a general view of a building and somebody talking inside of one of the offices. In the next drawing we see the character continuing with his dialog.

Example of face to face.

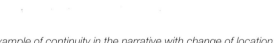

Example of continuity in the narrative with change of location.

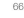

there are certain elements that must always be present to create tension in the story and to move the action quickly when necessary. To create drama, action, and suspense in the story, the artist must develop in detail situations that are complicated, unusual, and that may appear impossible to solve, from the moment the script is created. Each of these, linked together, will keep the reader's interest alive. This is important especially when the story is published in weekly and monthly magazines and newspapers.

Dramatization, Action,
and Suspense

THE LENGTH OF THE TEXT

The synthesis of action, drama, and suspense is found mainly in manga text. Texts and drawings must be concise and direct to sustain the reader's involvement, but the way the texts and the dialogs are developed is also essential. Everything that is said by the characters in the story is important, but the speed of the reading must be proportionate to the speed in which the action takes place. This way, for an action that develops at a frantic pace and which continues on the next panel, we cannot place long dialogs, because the perception of real time would be lost, and it would ruin the rhythm of the story. It is very important not to repeat the information, or to bore the reader by dwelling on details that have already been conveyed with the drawing or with the text. It would be pointless, for example, to have a drawing in which one character throws a punch at another while the balloon that comes from the protagonist says: "Here is another punch for you!" and the descriptive text reads: "Our protagonist punched him."

In this tense scene the dialog between the characters hinders the rhythm of the action. A story saturated with similar situations bores the reader even if the quality of the drawing is unsurpassable.

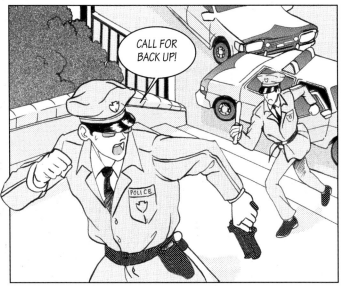

Here, the text has been simplified. Even though the characters are saying exactly the same thing, the action flows naturally.

The characters do not need to talk all the time. Sometimes, in action and suspense scenes, the absence of dialog can be significant and good for the proper development of the story line.

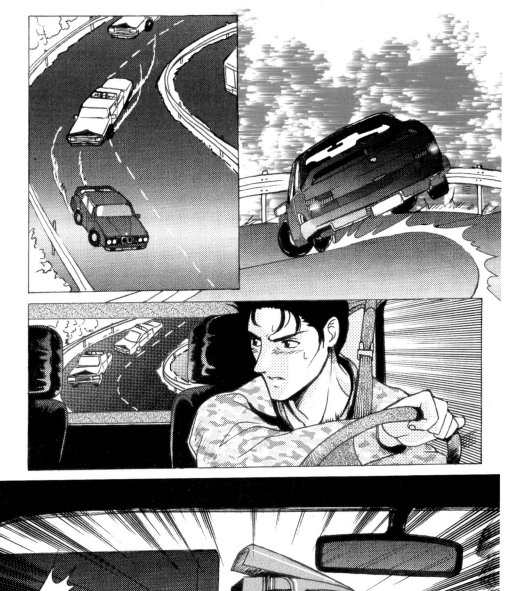

It is important to create adequate tension throughout the entire manga, so that the last drawing of the page is strong enough to motivate the reader to turn the page.

the elements of form are the ones that refer to the graphic approach and the "staging" of the story. We will see how these elements are extremely important within the narrative.

Elements
of Form

APPEARANCE AND EXPRESSION OF THE CHARACTERS

In some cases, the reader of cartoons expects the "good" character to have a good expression, and the "bad" one to have a bad expression; however, playing with ambiguity and not providing so many clues is interesting and makes the stories less predictable. In any case, stereotypes are the basis of every creation and help identify the characters easily, at least in their most characteristic features. The way the essence of each character is defined, in the end, is also what shapes part of the story.

THE FIGURE

According to the rule of stereotypes, male protagonists respond to the canon of an athletic build, well proportioned, with pleasant, masculine facial features. Female protagonists are more sensual and attractive. Mean characters on the other hand can have a grimy, disgusting appearance, or they can be thin, hawk-nosed, and with an unmistakable sneer on their faces, which becomes evident in their mean actions.

Example of a male protagonist character.

Example of a female protagonist character.

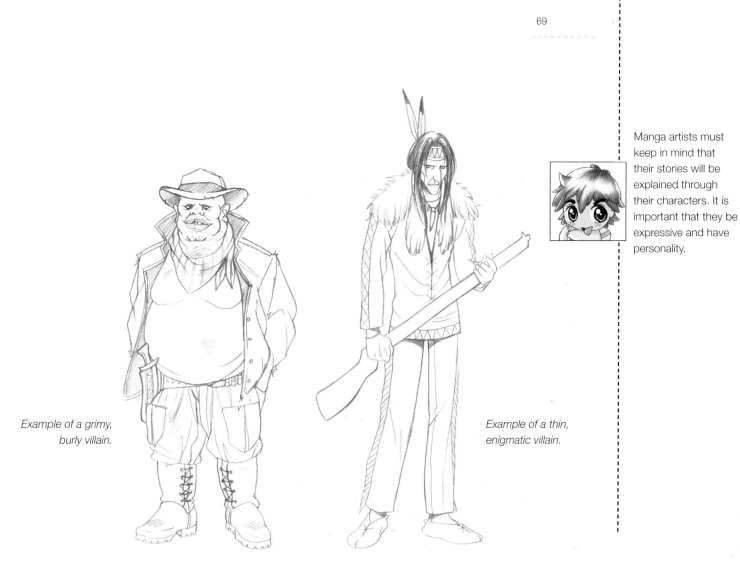

Example of a grimy, burly villain.

Example of a thin, enigmatic villain.

Manga artists must keep in mind that their stories will be explained through their characters. It is important that they be expressive and have personality.

THE FACIAL EXPRESSION

The physical appearance is important, but the expression is just as important. In principle and from his appearance, a character can convey a specific feeling, but it is his expression that tells us what his intentions are and through which we discover his true personality.

This single character adopts a very different role depending on his expression. In the first example he looks like a true seductive and manly protagonist. The second example shows him as a funny character that could represent anyone in our story, while in the third example we see an evil person with a wicked expression. We distance ourselves from the stereotypical approach to physical appearances, and we define his personality only through his expression.

The Setting

of the Scene

this is another element of form that contributes to the storytelling in a very significant way, thus it is important as a graphic element as well as a narrative one. The setting shows the surroundings in which the action takes place, and it also gives us information to help us understand the story better. To place properly the setting and the time in which the manga takes place, it is a good idea to work up a preliminary outline, taking care not to overlook architectural details, as well as the clothes and tools used by the characters that appear in the story.

Through just a few scenes created for a particular manga, we will be able to get part of the feeling of the action and the plot that are to come. This village where several houses can be seen burning, tells us that it has been attacked and looted by evil people and that—probably— some lonely samurai will soon take matters into his own hands.

General setting for a humble town that has fallen prey to looters.

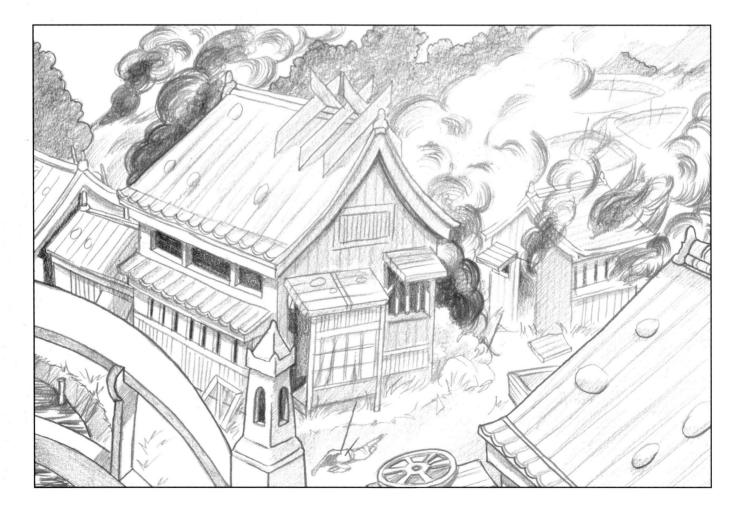

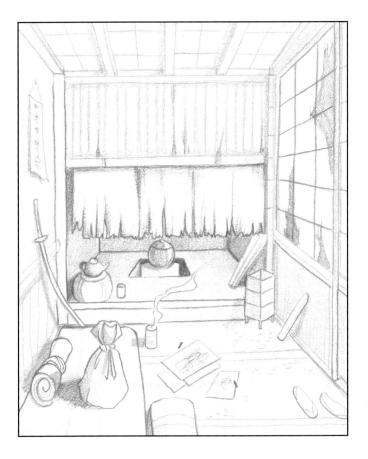

This could be the protagonist's environment, a temporary place typical of a nomadic character, but where we can see his belongings: weapons, backpack, etc. The lighting of the place conveys in a subtle way the personality of a person who is introverted, keeps to himself, and is looking for . . . justice? vengeance?

A background that shows details about the manga character. It is probably a wandering samurai looking for vengeance.

It will be necessary to do research to create appropriate environments for the stories. The background that surrounds the characters and the surroundings where the action takes place will make the manga believable.

This wide view could be the general headquarters of villains. The leftovers of a large meal and elements of the loot indicate that somebody has celebrated their victory over disadvantaged people. The throne that is located in the room suggests the presence of a leader, who is probably tough and cruel.

The background for a possible general headquarters and main objective of our protagonist.

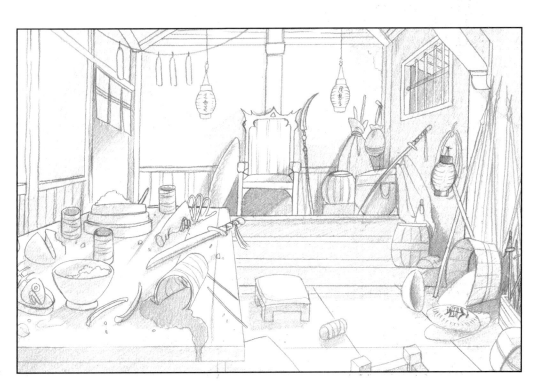

The Composition
of the Panel

It is very important to direct the focus of the reader to the essential part of the panel, in other words: to find unity within variety.

Excessive unity can create monotony in the story and boredom in the reader, while too much variety can produce visual fatigue and tiredness. The key is to achieve the appropriate balance in each case.

THE CENTER OF ATTENTION

The artist's work is "to guide" the reader toward the center of interest in the panel, besides trying to make the overall page rich with various framing styles, by changing the visual angle, contrasting and highlighting the elements of the scene with whites, grays, and blacks, etc. The important thing is to show what we really want the reader to see.

This example shows a situation that takes place in a classroom, but the artist, although he has chosen a daring approach, has overlooked the composition of the scene by cutting off the heads of its protagonists. From the picture we guess that the scene being portrayed is a classroom. The character that is most visible could be the protagonist of the situation, but we miss his demeanor. The drawing lacks interest and significance because the drawing has been composed incorrectly.

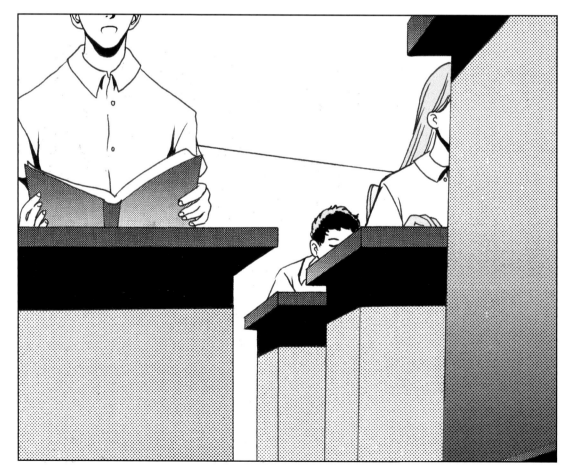

Vignette with incorrect composition.

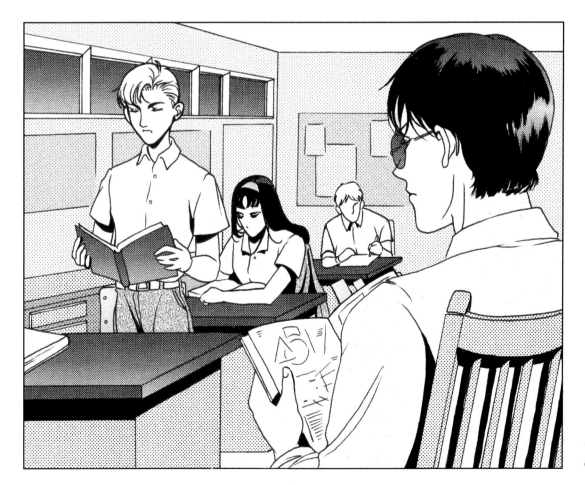

To achieve the most appropriate composition in each panel, it will be necessary to make a few sketches to approximate the idea that the artist wishes to convey.

In this case we are able to see the situation clearly. The teacher's back is to the reader at a three-quarter angle, and we can guess the demeanor of the student in front through his expression. The rest of the surrounding places us unequivocally inside a classroom. This composition has been laid out correctly.

EXAMPLES OF COMPOSITION

There are different ways of composing a panel. We can do it in depth, in such a way that the elements are grouped together and superimposed, making sure at the same time that they are not isolated. Or, we can use contrast, chiaroscuros of light and shadow, whites and blacks to emphasize a specific part of the drawing.

The composition can also be symmetrical or asymmetrical; an asymmetrical composition provides a dramatic feeling, while a symmetric one expresses greater formality.

Vignette with correct composition.

THE SYMMETRICAL COMPOSITION

The symmetrical composition gives the scene a theatrical feeling; all the masses are so equally compensated, all the content of the drawing is so uniform and "perfect," that the final result may appear flat. The symmetrical composition would be perfect for emphasizing formal moments related to majestic scenes, royalty, etc., but perhaps it is not the most appropriate one for providing movement to the drawings.

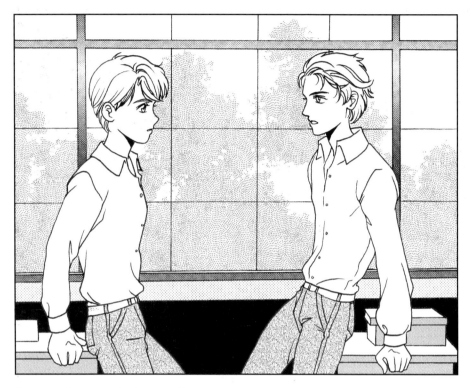

Example of a symmetrical composition.

Example of an asymmetrical composition.

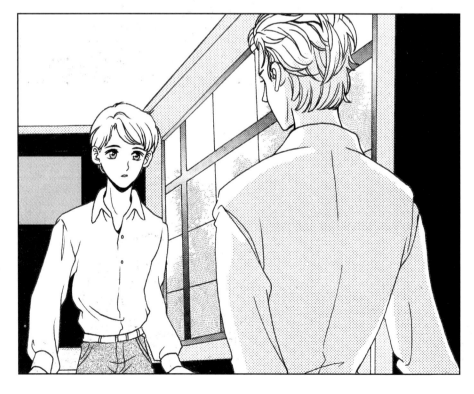

THE ASYMMETRICAL COMPOSITION

Here the same moment of the previous drawing is depicted but with an asymmetrical composition. The scene has greater depth and has become more interesting. A more dynamic approach to the drawing brings more attention to what is happening in the scene. Generally, asymmetrical compositions are more effective.

Right. Examples of compositions based on simple geometric forms. Any major figure can be reduced to a geometric shape that is easily recognizable. This approach helps the eye to find the drawing's center of interest, and at the same time, balances the composition in such a way that the final result is harmonious and pleasing to the eye.

the layout of the panels, together with the script, are the main tools that the artist has to tell the story. The *mangaka* selects the appropriate panel for each scene to show the reader the essential elements necessary to understanding the plot. In reality, the task is not limited to drawing attractive images inside each panel. What is really important is that the purpose of each is to show the reader the elements, characters, and situations that will take him or her through a gripping story. In the following sections we will present the most common panels, as far as cuts and angles, that appear in manga.

Narrative Dramatization
with Panels

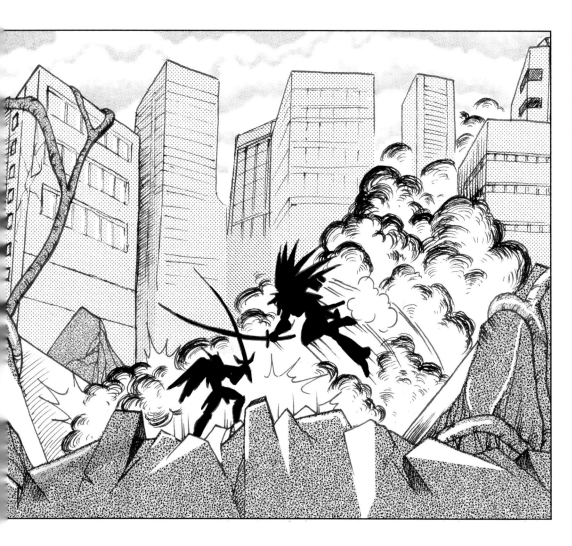

Cartoon drawn as a wide-angle view.

WIDE-ANGLE VIEW
The angle of the cut of this panel is the largest one possible. It makes it possible to show large spaces that transport the reader into the environment where the action takes place. It provides maximum visual information.

We can use it at the beginning of each chapter page as an introduction panel or save it as a dramatic element for the moment of climax in the action.

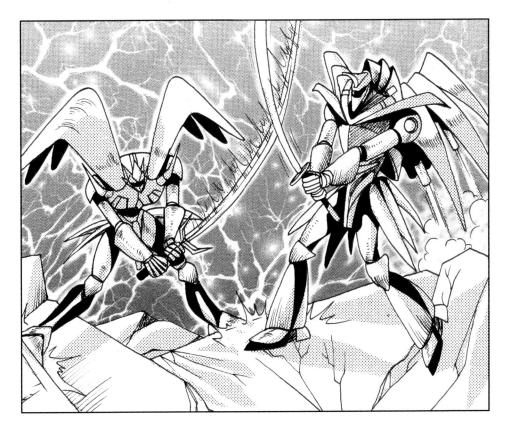

NORMAL VIEW

The angle of the cut of this panel is closer than the previous one. It shows the characters at full length, as well as the details of their gear, features, and expressions. We continue to get a great deal of information about the setting, and the reader is easily transported to where the action takes place.

Cartoon in normal view.

AMERICAN VIEW

In the filmmaking world this panel is used to show the characters from just above or below the knees. In Western comics and in manga, it is normally used the same way. It is an ideal way to emphasize a character's demeanor, since it leaves out the feet and half of the leg, without a doubt the least expressive parts of the body.

Example of an American view.

MEDIUM VIEW

The angle of the cut for this cartoon is at the waist level. The information about the setting is very important, but this time the information about the character's face and its expression is more important.

It is a very useful approach for the narrative since it allows the transition on to more general or to closer panels without much visual difficulty on the part of the reader.

A drawing showing a medium view.

CLOSE-UP

The angle of the cut in this panel is placed at the neck level in such a way that the character's face occupies practically the entire visual field and it appears as the only dramatic element.

Example of a close-up.

DETAIL

This angle is used to emphasize a detail or fragment of an object or a character. It is used to direct the reader's attention to something very specific that will be of vital importance in the development of the plot.

Example of a detail.

The panels that we have seen so far have to do with the angle of the view. Next, we are going to present the ones that have to do with a visual angle.

HORIZON LINE

The perspective that we offer with this panel is located at the horizon line. It provides the narrative with objectivity, since we see the drawing the same way we perceive our most immediate surroundings, which is the viewpoint that is closest to the reality seen by the eye. This panel is very natural to the reader.

Illustration drawn at the level of the horizon line.

DOWNWARD ANGLE

This panel shows a point of view that is placed slightly above the horizon line; we see the characters and the objects from above. If we use this panel for general views or for extreme general views, we get a bird's eye view. This approach is very useful to describe backgrounds and the surrounding area; however, if we use it directly over a character we can project a psychological feeling of inferiority about something that is happening or before somebody who is observing him.

Scene in downward angle.

UPWARD ANGLE

The point of view is below the horizon line, and as a result, we see the scene from below. The psychological feeling that is conveyed by this panel when we center it on a character is to show us superiority and importance. The upward and downward angles emphasize the perspectives and highlight the characters.

Dramatization of a character seen at an upward angle.

TILTED ANGLE

This perspective is useful for conveying feelings of chaos, unbalance, and tension. The idea is to make the reader feel the same experiences that the protagonist of the scene is feeling. Sometimes, it is even possible to replace the background with action lines placed at an angle to create greater confusion in the drawing.

Example of a panel drawn at a tilted angle.

TATAMI ANGLE

This point of view is at a floor level. This perspective is commonly used in manga whose origin is attributed to Japanese film, especially to the director Yasuhiro Ozu.

In Japanese film, as in manga, it is common to show people eating the typical sushi from traditional Japanese cuisine, seated on the floor on pillows or on *tatami* mats (where the name comes from). The objective of this perspective is to show the same point of view of the characters.

Tatami *angle, a common perspective in manga.*

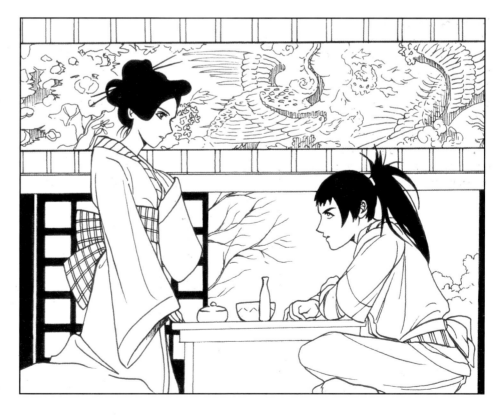

The Layout

of the Page.

Everything we have seen so far

has been related to

the structure of the narrative of the drawing: how to create good narrative rhythm, movement, dramatization. We have dealt with the background, the composition, and various settings. However, each panel that has been created will form part of the overall story that is the manga, and that constitutes the page. In the following pages we will see how to make a series of drawings tell the story. It is not only a matter of "filling in" spaces with wonderful drawings, because by themselves they lack interest. When planning a manga, the artist has to think globally, in its totality, so each page is the result of preliminary meticulous planning.

One page by itself, with its structure and the layout of the panels, can provide a lot of information: we can make the reading dynamic or slow and contemplative. It is important to fit each page into the content of the story.

The Rhythm of the Reading
of the Page

In Western cultures, reading is done from left to right, and this is how we will design our pages, unless of course, we are working directly for a Japanese publisher.

A single panel is the smallest unit of time and space in a manga. Later the page will include several of these units, which together will contribute to the development of the story page by page. It is important for the reader not to lose the thread and to follow the narrative in a natural and fluid way. To achieve this, the pages should be designed with a clear and legible structure, and in such a way that they do not create confusion.

We have divided our page into five panels. In the example on the left, the first panel is a wide-angle view, which we use to place the reader in the environment where the action takes place. The rest of the panels narrate the action itself. Notice how the rhythm and the order are clear and organized.

On the right, the page also is divided into five panels, but here the rhythm of the reading is broken up, since the reader will hesitate over which panel is second and which is third. The ideal approach would have been to reorganize the page in such way that this possible confusion did not happen.

Panel layout on a page that does not create confusion.

Panel layout on a page with the potential for ruining the proper reading rhythm and order.

Manga can have different designs for the panels. The important thing is for the page to be dynamic and appealing and that it gives the reader a visual approximation to the narrative content. There is no reason for using panels that are perfectly square and framed if our story requires a more dynamic page layout. However, if we combine different panel shapes, the overall look has to be taken into account to produce an effective result.

The design of the panels that are presented on this page gives a general idea of a dynamic content, which could be the premise for an action page. The first panel with a normal view shows a specific situation, the four tilted panels themselves provide a sense of movement, and one last oblong panel shows a final conclusion or a tense ending that entices the reader to turn the page to discover what is going to happen.

Page layout for dynamic content.

Examples in which the layout of the panels has been designed to create a natural reading rhythm.

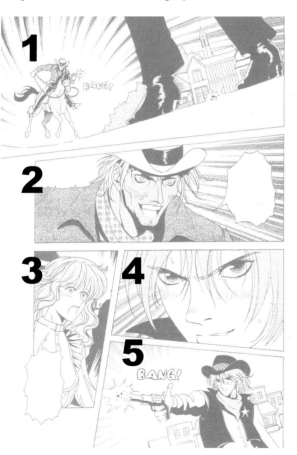

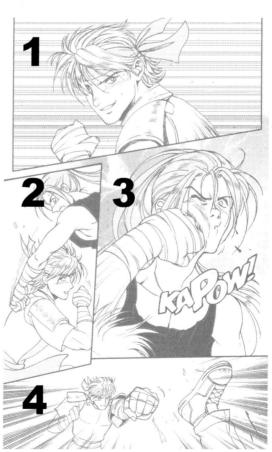

Panels
and Their Different Framing

the panel contains a graphic element: the illustration that is inside of it. The graphics alone should provide most of the information. There is also a narrative or literary element: the various texts that will appear inside the balloons or descriptive texts. This information should be very concise and simple; it is not a matter of writing long discourses, but to stay close to the rhythm of the action with the essential amount of reading. Last, there is a third element, also graphic: the panel itself. Most of the time we will use a panel to frame an action; however, sometimes, the panel itself will be a very strong narrative element, since, depending on its shape, the reader can be psychologically motivated in different way.

PANEL WITH NORMAL FRAMING
The framing within a panel will guide the attention of the reader to the elements it contains. It is a good idea to frame the panel so the attention of the reader is directed toward specific aspects of it.

Panel with normal framing.

In manga we can—occasionally—find extremely decorated and personalized panels based on the author's requirements at the time.

A tilted panel is not limited to reinforcing the scene's action; it also gives vitality to the overall look of the page.

Another variation of the normal panel frame is found mainly in *shonen* manga, whose important characteristic is exhilarating action. It is very important—as we will see later—that the composition of the page have a dynamic structure; therefore, we find panels framed with a normal format, but tilted in such way that they by themselves convey movement and give the content of the story narrative momentum.

FREE PANEL

When the drawing is not contained inside a panel a sense of spaciousness is conveyed to the reader. After studying the overall composition of the page, this approach can be used where the story requires the characters or the scenery to "breathe" and to give a feeling of open space.

Open panel.

A panel with a jagged frame.

PANEL WITH JAGGED FRAME

This panel will support any scene that is contained in it. It will help to psychologically reinforce a feeling of danger, a violent situation, or an aggressive action.

It should be used in moderation and only for the cases mentioned above. We should remember the immediacy of a warning signal and that it should be followed by a specific and determined action. Also, an aggressive action is very fast; therefore maintaining a series of panels with this type of situation and specific format would ruin the action and would not be consistent with its sequence in real time.

PANEL WITH A CLOUD FRAME

This tells the reader that what is happening is, perhaps, something unreal or a situation that only takes place in the character's dreams, thoughts, or memories. It leads us to believe, without a doubt, that what we are reading is not really happening in the story, but is part of the imaginary world of one of the characters.

Panel with a cloud frame.

The author can take some creative liberties to introduce new elements, as long as they can be understood and interpreted by the readers.

Trapezoidal panels are used to show various fast movements in the story very quickly. If the artist were working with normal panels, he or she would need two of them: one to show how the hook advances and one to show how it tears the protagonist's dress. Using trapezoid panels, the action can be communicated still using two panels but within the space of a single panel.

A SERIES OF TRAPEZOIDAL PANELS

These are ideal for showing action or for illustrating situations of exhilarating dynamism. Generally, these panels provide movement to the narrative, and they can be configured at different angles depicting perspectives that convey tension in dramatic scenes. However, they can also be used to show close-ups.

In the case of more private scenes, trapezoidal panels also show different moments of an action, reducing the reading time.

to complement our manga pages, we have different text elements that will help us emphasize and highlight different points of the dialog and of everything that is happening in the scene. While these elements are also used in Western comics, there are some special features that make them unique.

Text Elements
in the Drawing

BALLOONS

Most of the text that appears in a manga is placed inside balloons. The author chooses the appropriate placement for each balloon, avoiding those that will compromise the view of a character or of important elements of the drawing. The layout for the panels is designed according to the spaces needed for the balloons. In general terms, a balloon should occupy no more than a third of the overall area of the panel, but this is not a fixed rule and every author has his own guidelines.

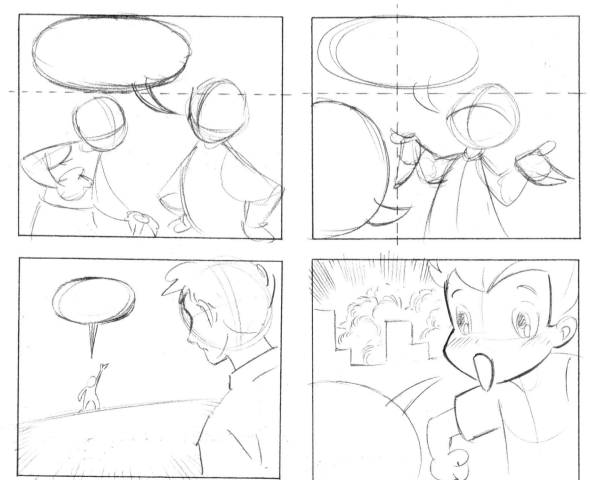

Different points where a balloon can be placed in a panel. It usually occupies one third of the space, but the author is the one who defines the placement of each balloon.

Allowing a text balloon to stick out or to overlap one or more panels can be a good graphic approach that can make the story more dynamic and appealing.

Common balloons for Japanese texts.

THE SHAPE OF THE BALLOONS

The balloon's shape varies according to the dialog's content; in this way we help the reader "nuance" the speech the same way the protagonists of the story would. There is a universal code in this respect that tells us that the different forms of a balloon correspond to different "tones." Shown here are some of the most representative balloon samples.

The most commonly used balloons are round, oval, and rectangular. They are used for conventional dialog situations between characters. The "tail" is a special feature, which points to the character who is speaking. As a result of the different requirements of Western and Japanese lettering, the shape of the balloons can vary. Balloons for Japanese characters are commonly vertical.

Common balloons for Western texts.

Common rectangular balloons.

Balloon for descriptive text.

Balloons for descriptive text are not very common in manga. They are used to include narrative or "offstage" voice texts, text that describes situations or scenery, and even to indicate leaps in time like, for example, "In a different part of the city" or "The next morning".

These texts are most commonly found alone somewhere in the panel without a balloon around them, although some authors use them often.

Cloud-shaped balloons are used when a character is thinking about something, and they are connected to him with little circles. Here, fantasy plays an important role; if we want to indicate that a protagonist is thinking about her hero, we can, for example, substitute hearts for the little circles to show the love that she feels for him.

A less common formula is to place "floating" text in some part of the panel close to, or actually inside, the character that is thinking.

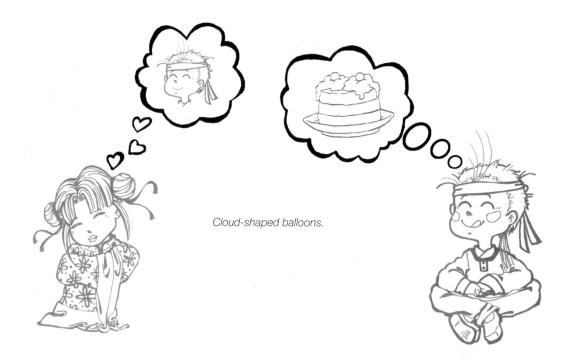

Cloud-shaped balloons.

Jagged balloon.

In manga, texts are usually written with smaller letters to show when a character is speaking in a low voice. Sometimes part of the text is included inside the character to suggest what he is thinking.

The jagged balloon is used to indicate that a person is screaming a warning about something dangerous, and also, to depict the voice that comes out of some electronic device.

The dotted-line balloon is not very common in manga, but it is used to show that a character is speaking in a low voice.

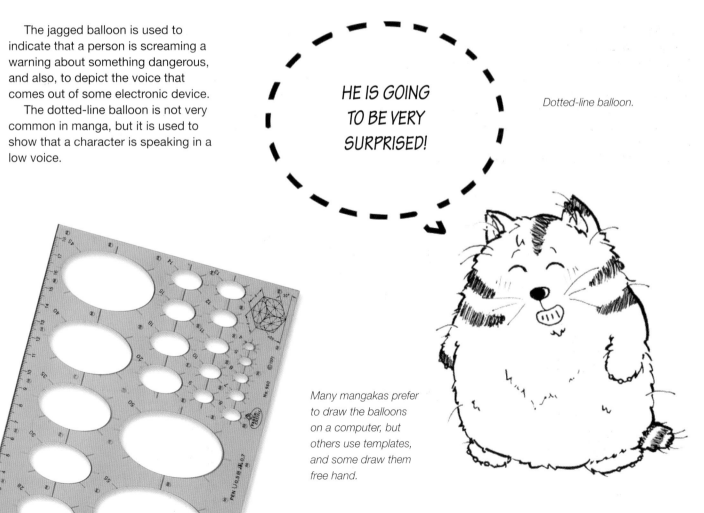

Dotted-line balloon.

Many mangakas prefer to draw the balloons on a computer, but others use templates, and some draw them free hand.

SOUND EFFECTS

These texts appear outside of the panels and represent the sounds that things make. In Western comics sound effects are often seen accompanying sudden sounds, such as shots or explosions, or sounds that add something to the story, such as slowly opening doors, footsteps, and so on. In manga, sound effects are used, not only to represent all these sounds, but also for imperceptible sounds like breathing blinking, or smiling.

Sometimes, the definition of the action itself is used as a sound effect, so if one character bites another the word *kamitsuki*, which is "bite" in Japanese, is written instead of the classic sound effect "chomp," which we would use in English.

Sound effects have their own aesthetic value since it is not only a matter of writing the "sound" of an action but of integrating it into the drawing. Some artists come up with creative graphic ideas.

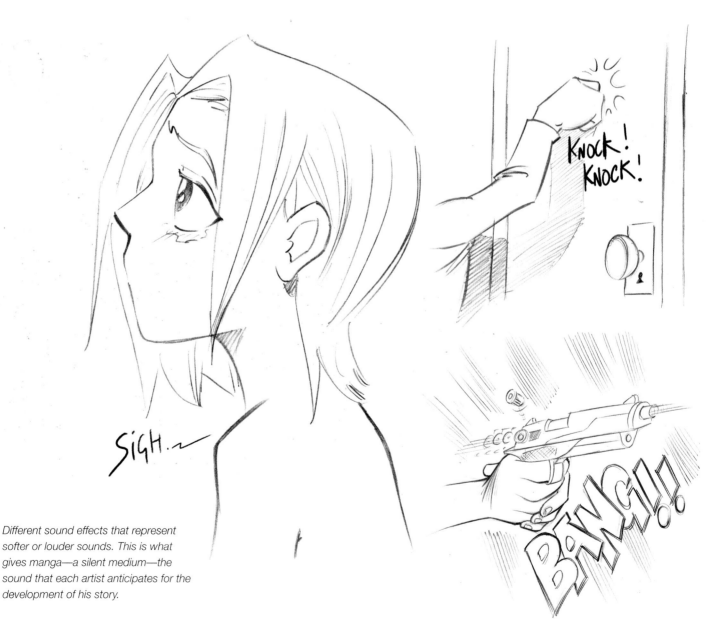

Different sound effects that represent softer or louder sounds. This is what gives manga—a silent medium—the sound that each artist anticipates for the development of his story.

LETTERING

Lettering refers to the text that appears inside the balloons and that represents the dialog of each character. It is very important that the lettering be clear and easy to read. In general, the entire manga is written with the same type of letters in every panel, with the exception of some variations to emphasize the text.

In a dialog, some words or sentences can be written in bold or cursive to emphasize that part of the text and to make it clearer. The letters can be made bigger and even shaky when, for example, a character screams, finds himself in a dangerous situation, or is scared. Certain characters that, due to their particular characteristics, are absolutely different from the others can have different typography that sets them apart in an unmistakable way.

The example of fantasy typography used for the lettering of a robot's mechanical voice magnifies the dramatic effect of the panel.

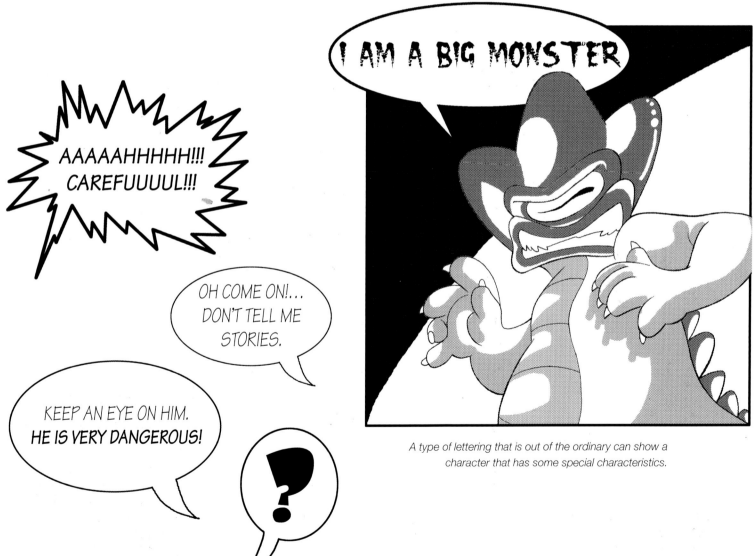

A type of lettering that is out of the ordinary can show a character that has some special characteristics.

Examples of text in balloons and some of their variations.

Elements for Graphic

Reinforcement

there are numerous graphic elements that the artist can include in the panel to add new meanings. Some are used to show speed, movement, direction, and so on. Others are used to express a state of mind or a specific situation graphically. In manga, this is one of its main characteristics.

Graphic elements are a code of symbols established by the author. Some of these symbols are universal, others are specific and personal to each artist; in any case, the important thing is for the code to work and to create an understanding between the author and the reader.

Different examples of motion lines.

MOTION LINES
These are lines drawn in any direction and inside of the panel. In general, they replace the background, and it is understood that the author has already properly placed the reader in the location where the action takes place. The purpose of the motion lines is to convey the feeling of directional speed and of movement in order to create a more dynamic narrative.

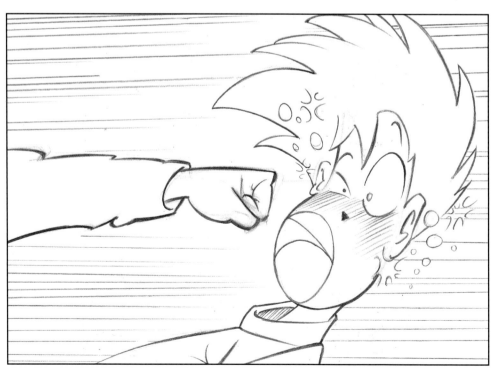

EXPRESSIVE SYMBOLS

These show situations in which the characters experience a specific state of mind. In other words, they reinforce the expression by exaggerating its meaning and establishing complicity with the reader. Most are universal and easy to recognize.

A

B

C

D

E

F

G

H

A. This girl has just had a brilliant idea.

B. Extreme anger including insults.

C. The large drop typical of manga shows that a character feels ridiculous or uncomfortable when faced with a specific situation.

D. A throbbing vein on the temple indicates that a character is very disturbed.

E. A drooling character with a nosebleed signifies sexual arousal.

F. Blushing conceals the character's gaze.

G. The eyes come out of their sockets when a character is surprised by something.

H. The "X" shaped eyes express a state of unconsciousness or knockout.

A Narrative for

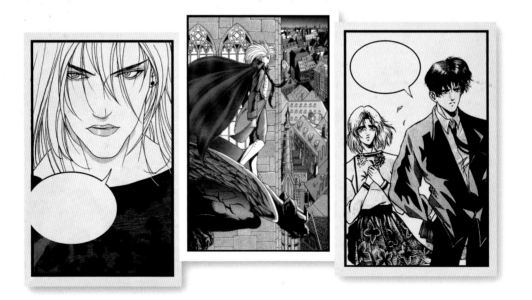

VANESSA DURÁN.
*PANELS FROM: KYRIE ELEISON (2002), SHEOL (1997),
AND CUANDO LOS PAJAROS NADAN (1996)*

Every Style.

We know that the narrative

in manga

has a universal format, and in the first chapters, we classified it by styles and by the ages of the audiences to which it is directed. Each style— *shonen*, *shojo,* and *kodomo*—has its own graphic, content, and narrative characteristics. It is not the same thing to narrate a story for adolescent boys as it is for girls; nor are stories treated the same way in a manga for adults and for children. Although there are narrative codes that are common to all of them, each style has its peculiarities and own characteristics that the author must know how to differentiate. In the following pages, we will present in a clear and concise way some examples from each style, the characters of each style, and how to design the layout of each page to reach a specific audience.

Shonen,
the Manga for Boys

Shonen manga is intended for an adolescent male audience. It is drawn by all types of authors and includes stories from different genres.

The stories related in *shonen* are of the style *doryoku-yuujou-shouri*, which means, "effort-friendship-triumph." We are dealing with stories where the protagonist overcomes obstacles that, in the end, guide him to his objective. They tend to be stories of personal improvement in which each new challenge presents more and more difficulties. Most of them are science-fiction stories or sports in which martial arts and school environments are predominant.

The dramatic elements that warn the reader about imminent dangers, which are followed by scenes full of action and tension, are very important. This does not mean that a *shonen* does not have moments of pure entertainment in between the action-packed scenes. On the contrary, *shonen* are full of humor because their protagonist characters have to present themselves as nice, funny, and charismatic.

The structure and composition of the page has to be very dynamic; the trapezoidal panels must convey a feeling of movement and be spectacular in nature all the time.

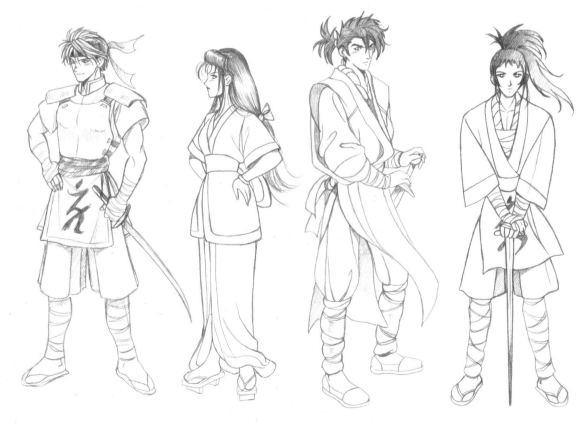

Examples of shonen *characters. The protagonists usually are very good hearted and are involved in grave situations that they must solve. Their character is noble and loyal, unlike their antagonists, who are usually relentlessly cruel.*

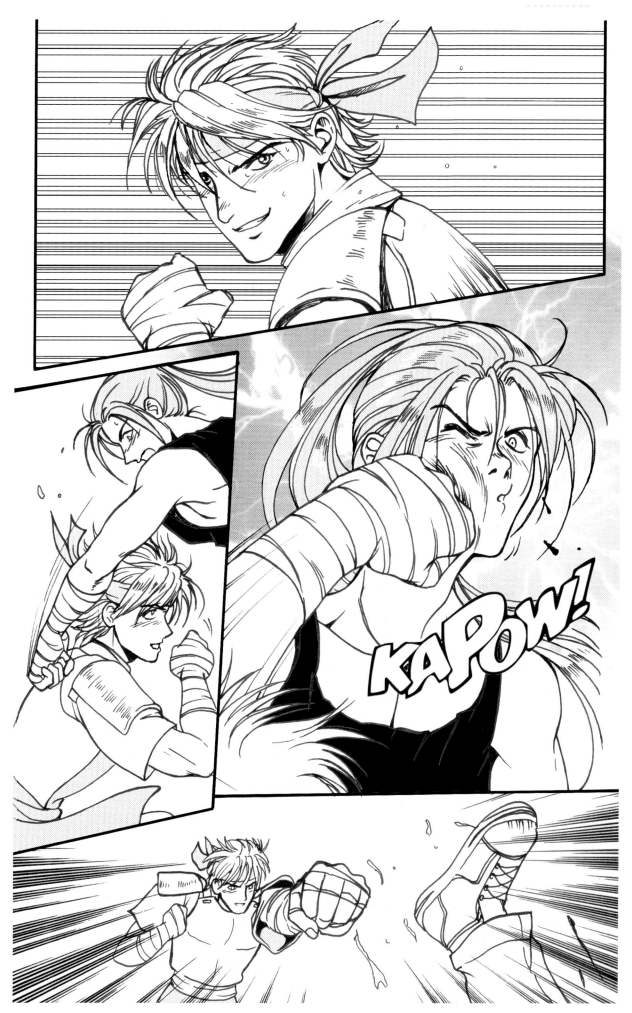

Example of the layout of a shonen page with its characteristic panel, content, and narrative structure.

this is a manga intended for adolescent female audiences. As with *shonen*, this style is used by authors that work in all the genres and that use every type of content.

*Sh*ojo,
or Manga for Girls

These stories try to reflect, above all, the feeling of the protagonists, and, independently of the genre used (*bishojo, mahokka,* etc.), they commonly have a strong romantic content that is maintained throughout the entire story. Normally, the female protagonist falls in love, and all of a sudden there is a conflict that places the characters in a difficult situation that forces them to make decisions and to analyze their feelings at all times. The conflicts become entangled with love triangles and with any other problem that endangers the love relationship.

Humor is also commonplace in *shojo* stories. It is welcomed, if only to break up the tension of the drama; proof of this is that even though the *shojo* style is more or less realistic, the graphic elements that are used in it tend to exaggerate it.

Shojo narrative is based on a concept of aesthetics where the important thing is to exalt the beauty of its characters, the surroundings, the clothing, and even the overall composition of the page and in which the contemplation of feelings and emotions prevails over the action. This creates a rhythm of reading that is slow and introspective because much of what happens in a *shojo* takes place in the mind of the characters. There are many close-ups and open panels that provide a bucolic background.

Since this style is gaining more and more followers, among which are many boys, the latest tendency is to blend feelings with action. What makes this style stand out from the others is, without a doubt, the authors' constant pursuit of style and beauty.

Shojo *characters. The protagonists are girls who fall in love with the male protagonist, and because they have to suffer so much to gain his love, they mature through the story. The characters are attractive and stylized.*

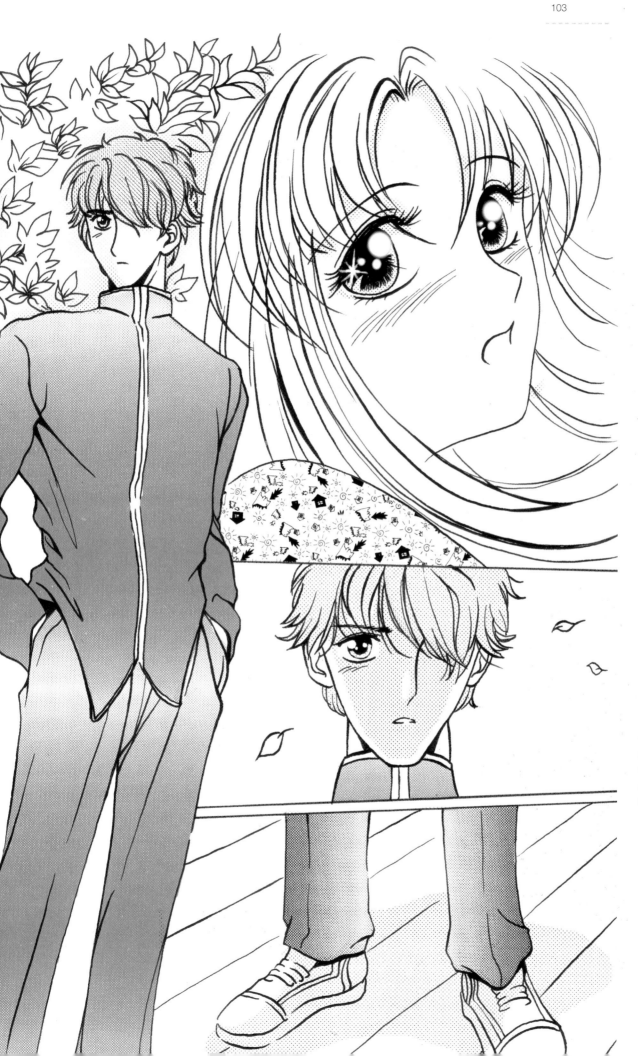

Shojo *page that describes how two characters meet, look at each other, and discover each other.*

Seinen,
the Style of Manga for Adults

Seinen characters drawn in a more realistic style and conservative proportions. They are usually not very stereotypical due to the great variety of the stories.

In reality, this is a manga for young adults between the ages of 18 and 25, but it is also appreciated by older readers who follow this type of adventure with passion. Again, we find ourselves with a variety of stories and authors that practice any type of genre; however, the stories that are developed in *seinen* are not used in *shonen* or in *shojo* due to the complexity of their content.

In *seinen* it is mainly the story that the authors are interested in. Since they have to please an adult audience, they are more complex and their plots are more elaborate. They usually take place in environments that are similar to those of "real life." Its protagonists are business men, *yakuzas* (mafia), etc., and humor leads into political schemes and police plots, where explicit sex and violence make their appearance in a more direct way. The protagonists are adults that do not fit into any conventional archetype, even though the legendary ruthless character of the "tough guy," who is both noble and yet driven by vengeance and resentment, while seeking his own justice, is often present as a protagonist or secondary character.

The narrative is much more conventional than in other manga styles and is reminiscent of Western comics. The content and the appearance are traditional and classical in style; the spectacular look of the *shonen* is absent in them, as is the stylized figures of the *shojo*, which gives way to a style where the proportions of the characters, the details, surroundings, and dialog contents are more realistic.

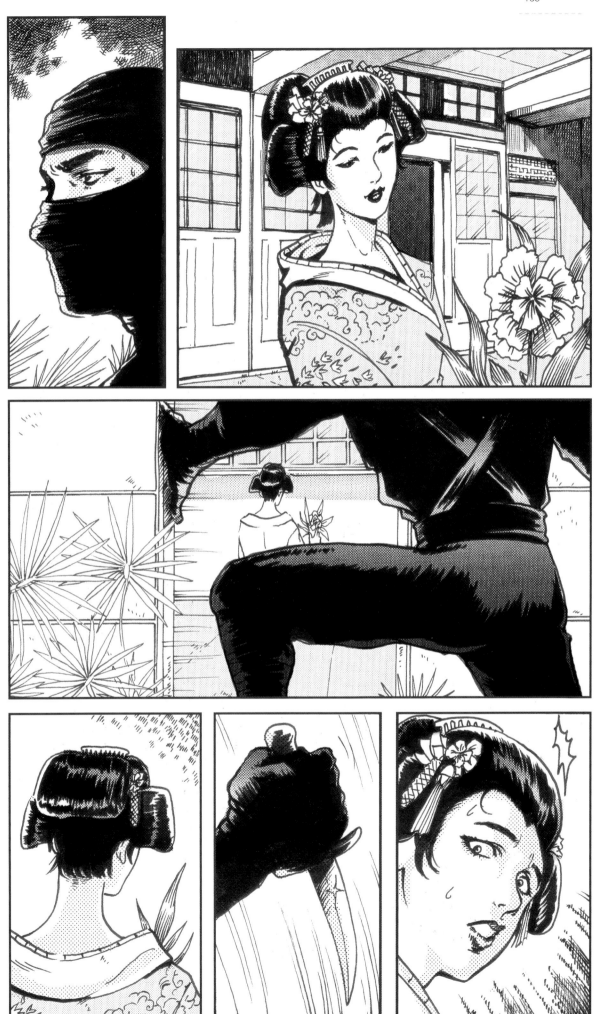

Seinen *page where the conventional narrative is similar to a Western classic comic.*

this is the manga for children. Here, the cartoon style and the humor are more evident in stories with funny, fresh, and witty contents.

The *kodomo* stories usually take place in everyday environments. The main protagonists consist of a central figure and his friends, his buddies, who will give him complete group support to make the interest and the humoristic content of the story exciting. Parents, teachers, neighbors, store attendants, and others take part as secondary characters and are usually the victims of the young protagonists' innocent mischief. Pets play an important role; they are usually dogs and cats that have absolutely magical, sometimes supernatural, powers.

Kodomo,
or Manga for Children

Generally, the characters fit into traditional archetypes. The idea is for them to be easily recognizable and their actions predictable.

Humor is the main essence of this style of manga; however, we also find some moral aspects in the most elaborate stories.

In terms of narrative, it is absolutely conventional, not as a matter of its looks but as a way of simplifying and making its content straightforward for a young audience.

Kodomo characters: the children that take center stage in the stories, the adults that try to maintain order with very little chance of success, the pets that sometimes are absolutely fantastic and have magical powers.

Kodomo *style page where conventional narrative of classic panels conveys simple ideas that are easy to understand.*

Creating the Char- acters

How to Draw

the Characters.

The manner in which manga

characters are drawn

is one of the key aspects of the story. In the following chapter we will tackle this challenge by showing how to construct faces and bodies according to the particular characteristics of each character, as well as how to maintain personality through the pose. It is important to keep in mind that in manga—as in Western comics—there are different ways of creating the characters depending on the narrative style that is chosen. For example, characters are drawn differently for adult audiences than for children and young people. That is why we have established a relationship among three main styles: realistic, stylized, and super–deformed (SD). In reality, manga authors usually work with all of these but adapt the style according to the story.

The True Protagonists
of a Manga

the characters are without a doubt what the reader relates to in the story. A character must exhibit all the essential elements that make him the true protagonist. From the beginning, it is important to give the character a demeanor that will help sustain the credibility, the tension, and the continuity of the narrative. However, in terms of the graphic approach for the drawing, the artist must create the characters by taking into account all the graphic elements necessary to flesh out the image of the protagonists so that the reader can fully understand the motives and the role that each one of them holds within the story.

In this phase of the process, research is extremely important not only in terms of the historic background—in cases where the manga reflects earlier periods—but also in terms of the clothing, accessories, decorative elements, and everything that relates to the surroundings in which the story takes place. Whether the manga deals with real facts or is based on fiction, it is important for the graphics to be created in a coherent way so that the reader can follow the adventures of the story without getting confused.

The features, the demeanor, the clothing, and the accessories of each character place the reader in the time and situation in which the story takes place.

Page on the right. The features, the expression, the demeanor and the attitude of each character convey to us the most outstanding features of their personality as well as what their motivation is going to be throughout the story. By his or her demeanor, we will be able to tell immediately if it is a character that solves problems or one who creates them.

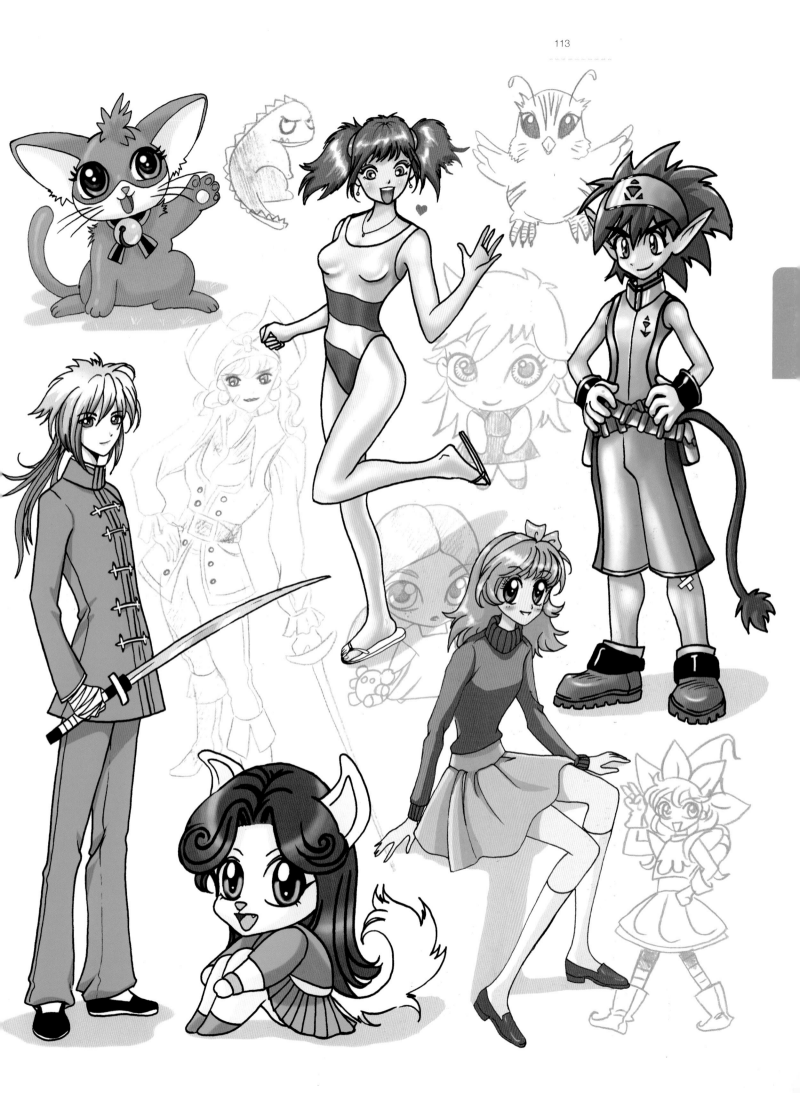

The Construction
of the Face

When the characters are being created, the artist has to be prepared to draw them over and over again with different attitudes, poses, and expressions. The characters carry us through the story panel by panel, and the reader has to be able to identify them every time. If the work is well defined the artist will be able to draw the characters as many times as needed, without losing sight of their proportions or the features that identify them. To do this, it is essential to base the drawings on geometric constructs that facilitate the general construction and help to keep the previously determined structural types and essential physical characteristics uniquely distinctive.

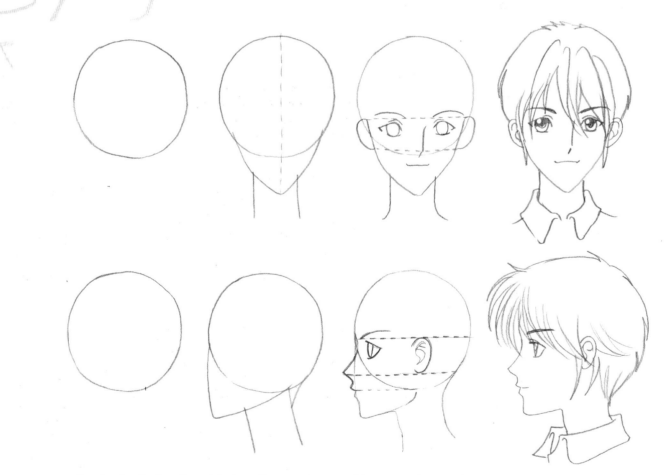

Constructing the face through juxtaposition of geometric structures and axes will help place the elements that create expression.
The cranial structure defines the intellectual capacity of the characters. A large cranial structure shows a character with greater intellectual capacity, while a small structure defines a simpler one. On this base we can begin to draw the axes that will become the eyes and the nose.

A good approach is to create the characters after real people that we know that fit the morphological characteristics of the protagonists.

THE CRANIAL STRUCTURE

We begin with the face. This is the most important part of the character, since it reflects the emotions, feelings, and mood changes.

We begin by planning its structure starting with simple round and oval shapes that define its cranial area.

Drawing the correct axes helps with the placement of the most important features: the eyes and the nose. These axes change, depending on the character's side view or three-quarter angle, and as a result, all the facial elements reflect these variations. Once the elements have been properly placed over the cranial structure and according to the axes used, we begin to add the details and finishing touches that make our character unique.

The cranial structure provides the shape for the head and at the same time conveys something about the psychology of the character.

The shape of the jaw structure gives the artist the layout for its construction and also indicates the psychology of the character.

THE STRUCTURE OF THE JAW

The next important element is the jaw. This structure will include the outline for the mouth. In general terms, the ears are located at the intersection between the cranial structure and the jaw structure. The jawbone also gives the reader an idea about the psychology of the character. A small and delicate jawbone indicates a fragile character; long and sharp jaw features define sinister characters; while square and angular jaws are indicative of strong characters that have the ability to make decisions.

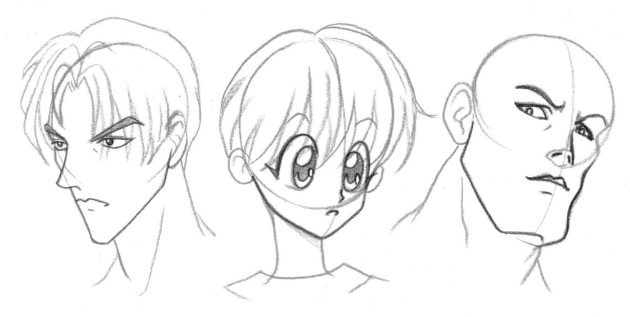

THE AXES OF SYMMETRY AND PERSPECTIVE

The axes of the face not only help the artist draw the expression of each character but also to construct the face in perspective.

The vertical axis divides the face lengthwise and shows the angle of the head, while the horizontal line indicates whether the face is looking up or down.

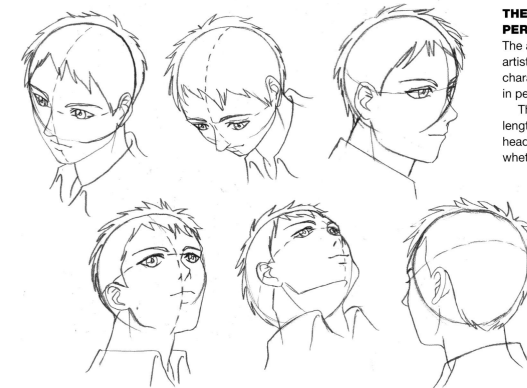

This face, seen from various vantage points, maintains its structure and depicts angles thanks to the help of the axes.

WORKING WITH OVAL STRUCTURES

We begin with oval and round structures to create the cranial and jaw areas. From this point on, the axes will help us draw the eyes, nose, and mouth, complete the details, and put in the final touches for each character. If we look closely, most of the manga characters follow this structure. Its apparent simplicity makes it easy to draw and helps maintain visual continuity throughout the story.

It is important to practice these structures to master the angles of the face and to try out the different psychological characteristics that can be attributed to a character with the various cranial and jaw structure combinations.

Using the same structures and modifying their sizes and shapes, we can create a great variety of characters only by changing the details that define each one of them.

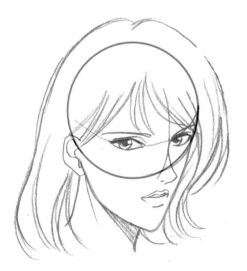

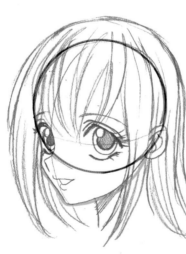

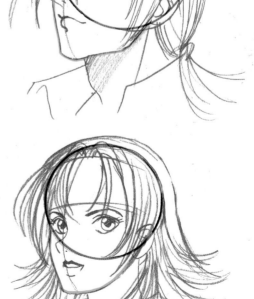

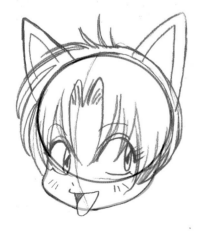

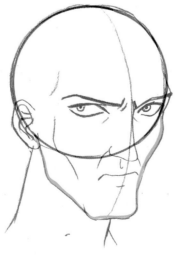

Constructing
the Body

a long time ago, classical artists established an ideal proportion for drawing the human body. It was an academic canon that divided the body into eight heads for the total height, which defined a perfectly proportioned physical structure. The same canon accepted the option of a height of nine heads to represent heroes, between six and seven for adolescents, and between four and five for children.

In manga, each artist adjusts this canon according to his or her own creative needs.

Each style has its own characteristics, and the discovery of new drawing formulas leads to interesting artistic solutions. The infinite variety of characters that can appear in a manga forces us to work with different canons; therefore, we can range from wonderful and heroic characters that are nine heads tall, to SD (super-deformed) pets and characters that range between one and a half heads to two heads, and protagonists, villains, and secondary characters that range between six and eight heads in height.

Classical canon for male and female characters that are eight heads tall, heroes with a proportion of nine, children with four, and rare and super-deformed characters with three, two, and even one and a half heads.

A good foundation in classical drawing is very important for any artist who wishes to work at his or her full potential in any field. In manga, drawings can be realistic or humorous in style; however, proper knowledge of the different elements of the human body, muscles, bones, and how the joints work is vital for making the bodies look natural, independent of the style used.

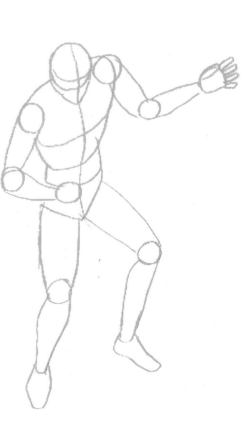

Constructing the characters by using the canons as a basic guide helps to maintain their proportions throughout the story.

The proportions that the artist decides to use, the construction with oval shapes to configure the head, the thoracic and pelvic areas, as well as the structure for the arms and legs, all bring out defining elements of the body that help us identify the characters.

The Pose and Movement
of the Figure

even though manga is a static medium, the characters that give life to the story must look natural and therefore be in constant movement. We must make each character "move" in a specific way according to his style, demeanor, and most important psychological features. The "pose" defines the personality and sets each character apart, even if we draw him or her in the distance or partially hidden in the shadows. Remember that we are able to recognize the people we know by the way they walk, their attitude, or by a simple glance at their most characteristic gestures.

This is exactly what the artist must achieve with the characters. He or she must be able to give them such distinct features that the reader can recognize them at a glance.

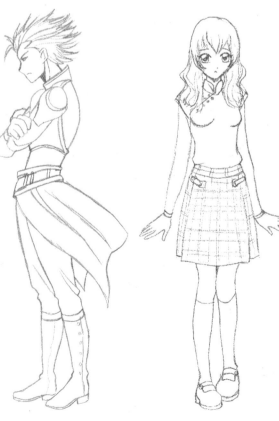

In these examples we can see characters with different personalities, intentions, and demeanors. It is not difficult to guess which one is the surly one, which one has a shy personality, and which one is self-confident and outgoing.

A simple pose defines the action that the character performs in the panel and, at the same time, shows the most significant personality features.

It is not the same to see a shy character suddenly engaging in a heroic act as it is for a character that is brave and arrogant. In both cases, the reader not only has to guess the intention through the pose but also has to notice that both actions originate from different personalities.

Even though manga is a static medium, it does not mean that the drawing should not be dynamic; on the contrary, we must be able to show movement in an effective way. In fact, everything that we have covered so far about narrative when planning and laying out the pages contributes greatly to making the story flow. If we add to that effective poses that properly describe the action performed by the characters, the objective has been achieved.

Dynamic mangas help the reader to identify with the stories, to get deeply involved in them, and to live them in a special way. The panels themselves are motionless but they must convey a sense of dynamic movement to the reader.

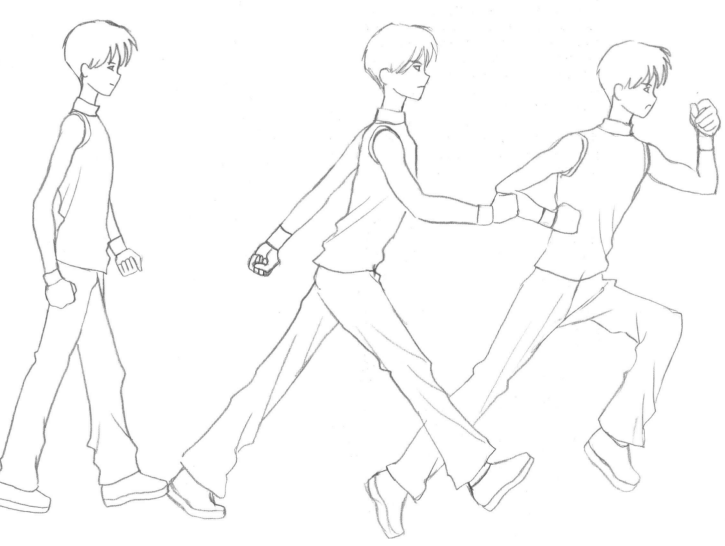

A single drawing must clearly show the reader which action the character is engaged in: strolling, walking fast, running, and so forth. The same thing is true for action movements and even for those in which the character appears to be passive but is feeling agitated inside.

DIFFERENT STAGES OF THE MOVEMENT

Manga artists have to know how to break down any action into different stages of movement. This will help them choose the most descriptive one when they need to explain a specific action with a single panel. It would be a good idea to make drawings from a life model and to work on quick two or three minute sketches of the most relevant moments of an action. It is a good exercise that helps sort through extreme and clearly recognizable poses, instead of halfway poses that leave the reader clueless and that can even confuse or lead to irreparable mistakes.

It is also helpful to look through sports and martial arts magazines, or through magazines on any subject. Any pose, in addition to being drawn correctly, must be properly researched. It is not enough to make an action spectacular; it must also be credible. It is important not to leave the characters half drawn or to have them make impossible moves. Every joint and every joint rotation has its limits, and we must respect the laws of anatomy for the action poses to look convincing. In the end, every author develops his or her own style, and his manga stories, and the poses that define and characterize them, are easy to recognize.

Different "moments" of a specific action: a character that is lying on the ground gets up. The artist should practice breaking down an action into its most important stages. This will help identify which pose defines an action better.

THE AXES

Manga is not only a static medium but it is also a two-dimensional one since it takes place on a piece of paper. The aim of the artist is to break the two-dimensionality, the unavoidable limitations of the medium, and to bring the figures to life in all their glory through the drawings.

The axes help us draw the characters in perspective, forcing the two-dimensional reality to become a scene that appears natural.

Each character is formed by a series of lines that, besides giving it volume, provides balance and stability.

The axes give the characters a sense of dimension; they provide balance and movement, and make the poses fit into the background. We must keep in mind the imaginary lines of the axes for any pose and action being developed.

The axes help us construct the characters with the correct angle, independently of the action being performed.

THE CENTRAL AXIS

This is the axis that keeps the character grounded. First, by keeping it balanced with respect to the ground when the body is motionless, and second by maintaining the dynamic balance while the body is moving.

With the appropriate pose designed around an imaginary central axis, the artist can portray any action by keeping the character balanced and not looking unsteady, which the artist wants to avoid.

The character is kept grounded using the central axis as a reference. These two figures show that even when the angle of the central axis is changed there is a feeling of balance and stability.

THE AXIS FOR THE SHOULDERS AND HIPS

This axis deals with the angle of the character on the flat surface and helps break the two-dimensional feeling of the sheet of paper. Besides, it provides great dynamic dimension to the poses, since for certain movements the human body makes a series of swings that make it look truly active. Although the axes for the shoulders and the hips can go in opposite directions and can make the body twist and turn, they are always conditioned by the central axis.

The axes for the shoulders and the hips give the characters a great dynamic feeling and make them look as if they have depth.

THE AXIS FOR GROUNDED FEET

This axis makes it possible to establish the pose reinforcing the balance and the angle of the figure, showing the characters as if they were solid and "real." When a figure is placed within the setting, it is important to maintain a relationship with the other elements. This axis is also useful for placing the characters in any setting and for incorporating them perfectly into their surroundings.

The axis for the placement of the feet on the ground will allow the artist to set the characters and to make them solid looking.

The axes are imaginary lines that are drawn during the sketching stage. We will use them for the correct placement of the figures and to draw them with the appropriate angle. Later, when the final drawing is done in pencil or ink, these lines can be disregarded.

We must remember that there are many styles of manga and that authors combine several of them until they find the style that best suits their creative personalities. Until now we have talked about the four specific styles that differ the most from one another: *shonen*, *shojo*, *seinen*, and *kodomo*. We are going to focus on them to define three main drawing styles: realistic, stylized, and super-deformed.

Proportions
for the Different Styles

REALISTIC

We find this style mainly in *seinen* and *shonen* stories, all with several significant differences between them, but always close to canons that resemble real life and that tend to be proportionate.

The realistic style in *seinen* is helpful for telling "real" stories. This style is suitable for dealing with plots that are very close to real life, for example, peoples' biographies, *yakuza* (mafia) stories, and manga for adults and working people in general who identify with the story that is being told.

The realistic graphic style in *seinen* is characterized also by the special attention that is given to anatomical details: hands, smaller eyes that look real, wrinkles, etc.

Basic structure of a realistic character in the seinen *style.*

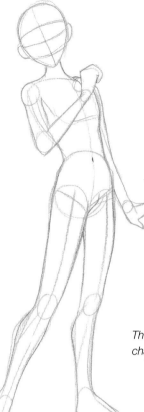

In *shonen*, the story plots are aimed at male and young audiences. As far as the graphic style is concerned, there are generally fewer details, the eyes are larger, the expressions are friendlier, but there is always a realistic approach, and in most cases the classic canons are respected.

It is also true that in *shonen* styles we can combine characters from the super-deformed style (which we will see later) to include little gags, or as a graphic resource to support some special narrative moment.

Experimentation opens up the doors to creativity and new tendencies. It is important to know the standard styles and to work with them, as well as to try out and combine others to find the most suitable formulas.

The basic structure of a realistic character in the shonen *style.*

Examples of realistic styles. The two on the left correspond to the seinen *style, where we can see that the artists have paid special attention to the anatomy: normal-looking eyes, and in general, well-proportioned details. The two on the right are in the* shonen *style, which also respects anatomical proportions, however, in this case the eyes are larger and somewhat exaggerated.*

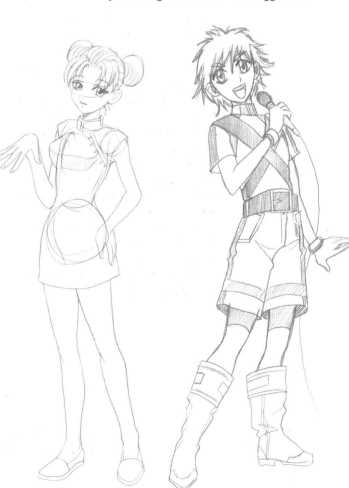

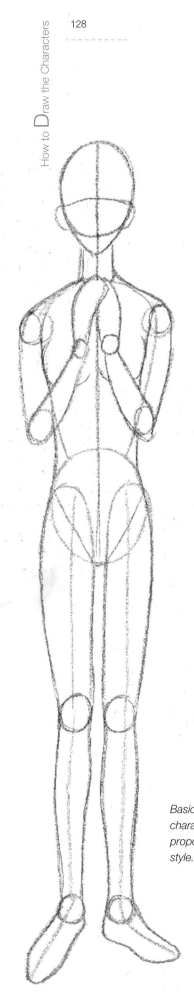

STYLIZED FIGURES

These are found almost exclusively in *shojo* stories. The main idea is to present very tall and stylized characters with highly idealized proportions, very suitable for manga with a romantic undertone. The authors of manga work in different styles and genres, and sometimes it is common to find *shonen* stories that are highly influenced by *shojo* or vice versa, depending on the author's specialty.

That is why sometimes it may be difficult to tell the characters of both styles apart; in that case, the difference is marked by the narrative structure of the particular story.

Stylized characters continue to look completely "natural." They may appear perfectly real, but their canon structure is far from real in terms of their proportions.

This page and the next one show examples of stylized characters that are typical of the shojo *genre.*

Basic structure of a character with stylized proportions in the shojo *style.*

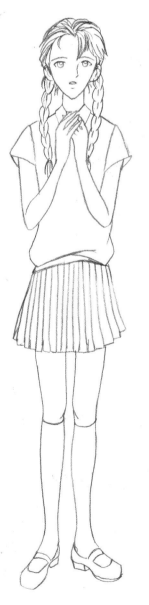

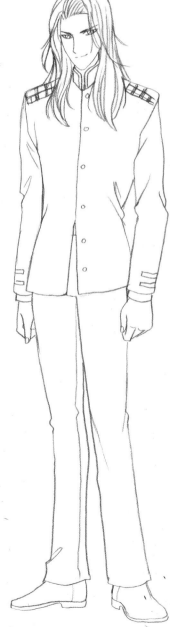

They are mainly found in manga for girls with romantic content. This is perhaps why the human body is stylized to the maximum, finding even characters with a nine-head proportion, but without the characteristics of a heroic character. In this type, the legs tend to be extremely long in proportion to the rest of the body, as are the the neck and hands. Sometimes male and female characters share these proportions to the point of looking very similar, and in the most extreme cases they become androgynous. In summary, thin, idealized bodies, large eyes with greatly exaggerated irises with many sparkly highlights, together with extreme elegance in its pure form, are some of the most important characteristics of characters with stylized proportions.

Some *shonen* stories have captivated female readers of *shojo* stories and vice versa. That is one of the reasons why both styles are increasingly similar. However, for a good observer it will be easy to detect their differences.

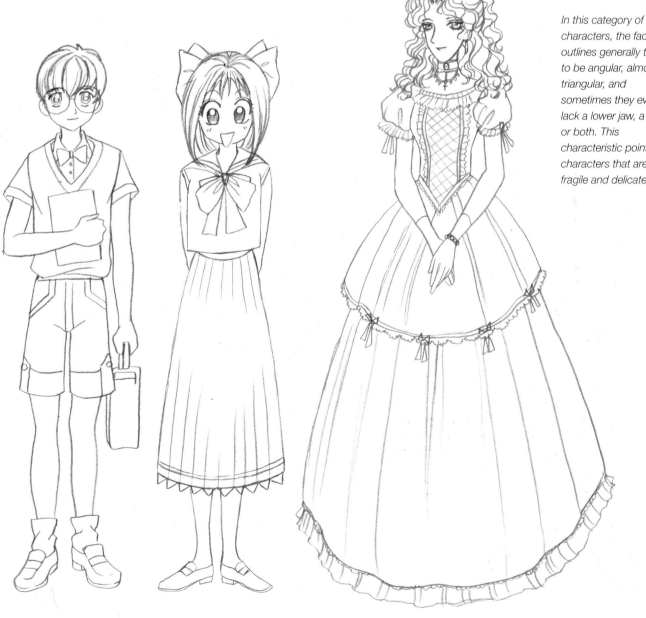

In this category of characters, the facial outlines generally tend to be angular, almost triangular, and sometimes they even lack a lower jaw, a nose, or both. This characteristic points to characters that are fragile and delicate.

Basic structure of a character of super-deformed proportions.

THE SUPER-DEFORMED (SD)

In general, this is a style of character used in humorous manga, sometimes for children and sometimes even as a narrative resource for a presumably "serious" manga. It is uncommon to find them in *seinen*, but these characters with enormous heads and small bodies can occasionally cross into some *shonen* and share the graphic universe with characters of that style, which are more realistic. They can, by themselves, be the protagonists of comic strips of the *yon-koma* style, or even of some manga in the *kodomo* style.

When they are shown together with realistic characters, with whom they have nothing in common at first sight, they can be a very useful resource that adds an important funny ingredient to the story, whether they are part of entire scenes or as a narrative element that expresses a specific situation in a given moment. For example, the most attractive and elegant character may feel ridiculous at a given moment and be shown in the scene as a caricature in the super-deformed style. The reader immediately understands that this is a funny or unusual situation for the character, and from that moment on, there is a sense of complicity between the author and the reader.

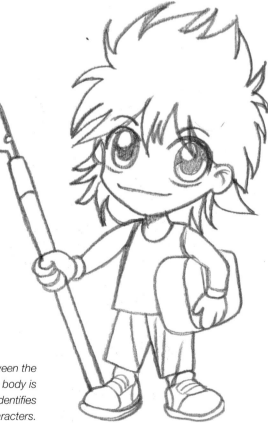

The proportion between the head and the rest of the body is the main feature that identifies super-deformed characters.

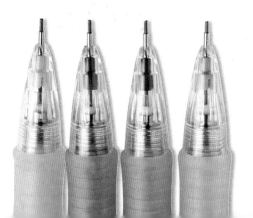

Super-deformed characters can be found throughout entire stories devoted to purely humorous styles, in scenes that are incorporated into *shonen* mangas, occasionally in some *shojo* as a narrative resource to show a character's emotion or situation, and even throughout stories that are parodies of popular series. A super-deformed is characterized by its proportion, which is two or three heads tall, and its enormous head that is half the size of the character's height. Other important aspects are the expression and a small body that adopts exaggerated poses.

Besides being used in funny stories, super-deformed characters are also useful for establishing a special complicity between the author and the reader in stories whose styles are more realistic, like the *shonen*.

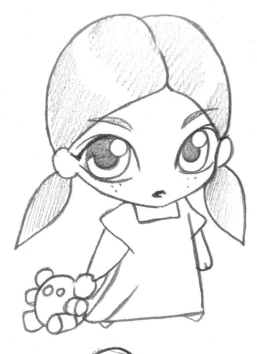

Examples of super-deformed characters. The face is usually the most characteristic feature, and as a result, the essential aspect of the character is the expression of the face with its large eyes. The rest of the features are simplified to a minimum.

Designing
the Characters

When we design the specific characters for our manga story, we must choose a style that is adaptable to the narrative. However, it also is important to have basic knowledge of all the styles. The latest trend in Japan is to combine styles and to include stylized characters in *shonen* adventures, or the other way around. It is always a good idea to experiment, which provides better graphic solutions.

With this in mind, we can plan how we want our characters to be. The decision in this area depends in great part on the narrative plot that is to be illustrated. First, we practice with the proportions that are most appropriate for the characters, and from there, we give them "something" special that makes them unique: the clothing, the accessories, the poses that emphasize the most outstanding features of their personalities, intentions and demeanor, their expressivity, and so on.

We study and justify the motivations of each of the characters based on the role that they play in the story. No character does something without a reason. Their actions are motivated by the premise of the story, which must be clearly reflected by their demeanor.

The characters are designed using the proportions and the style that best suits the story of which they are part.

The model sheet serves to establish the costumes and accessories of the characters. It is a good idea to identify on the sheet the accessories that the protagonists carry throughout the scenes.

THE MODEL SHEET

This helps the artist to get acquainted with the characters. It is used as a test run for the style and to practice their proportions, their expressivity, and their most relevant poses, which are probably repeated often throughout the story. It is also a useful reference as we develop the different pages of the manga.

The model sheet provides a permanent record of the characters created, which helps us maintain continuity and ensures that the characters are not drawn incorrectly or changed as the work progresses.

The model sheet is a useful reference in which we draw frontal, three-quarter, and back views of the characters. We must add typical poses that reflect their demeanor and also some of their most characteristic expressions.

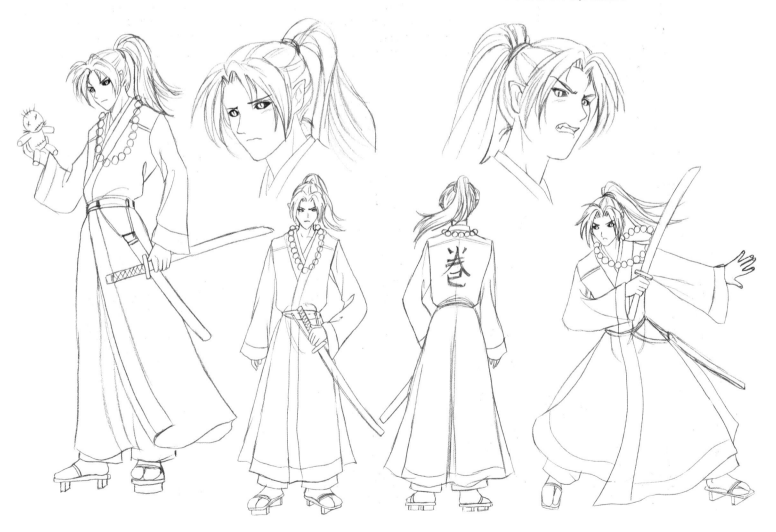

THE COSTUME

The documentation is basic in nature, and it reinforces in great part the credibility of our stories. We must know exactly how the characters of our manga dress, whether it is a story based on something real or imaginary. Clothes are not only a graphic element that enriches the narrative and makes it believable, but it is also an element that shapes and defines the personality of the protagonists in each adventure. Therefore, when the characters are designed, special attention should be given when we create each of the of their costumes, making sure that they always correspond to the time period and the surroundings in which the story takes place.

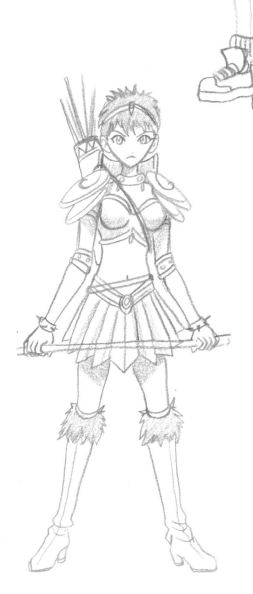

Examples of characters dressed in clothes that are appropriate for the setting in which the story takes place.

THE ACCESSORIES

As with the costumes, it is very important to learn about all the objects that are going to be used by the characters. It is simple in the case of ordinary everyday stories, since it is a matter of studying the most common elements and objects the even we probably use. A manga with a school story line that takes place in a classroom full of students is easy to illustrate because it only requires a quick memory recall and observation. However, a manga in which the accessories are not commonly used every day, such as weapons, vehicles for transportation, ornaments, and so forth, must be carefully researched. To narrate the adventures of a person that has a specific profession, it will be necessary to know very well the tools that are used to perform the job and how it is performed.

A very clear example, although perhaps extreme, is the manga *Black Jack* (1973) by Osamu Tezuka. In it, Tezuka narrates the ordeal of a young surgeon who, despised by his professional colleagues and envied for his mastery, is forced to practice in secrecy and to act as a mercenary of the scalpel wherever his talent is required. Tezuka, recalling his days as a medical student, describes with incomparable detail all the surgical implements, as well as the way that the different procedures are performed step by step.

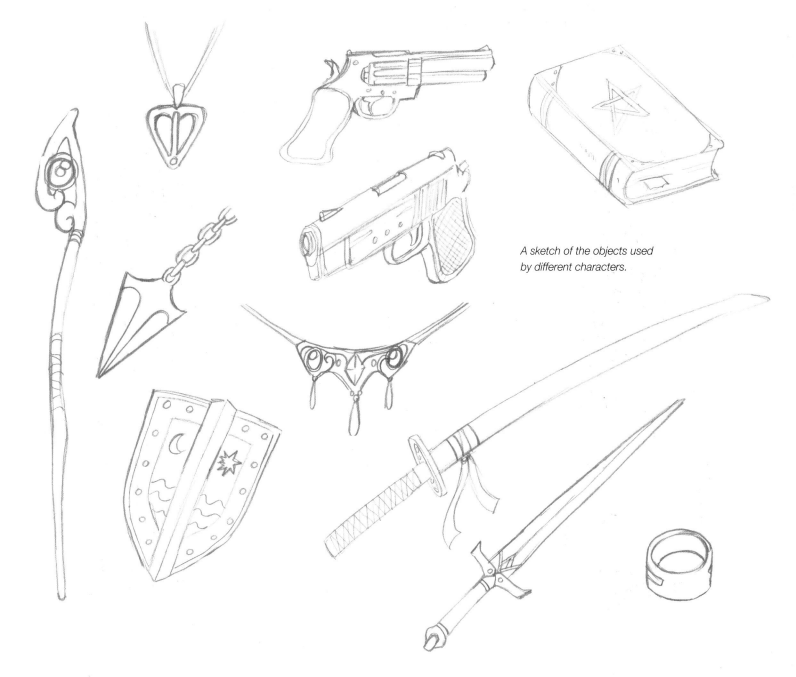

A sketch of the objects used by different characters.

Drawing Different

Characters.

Good stories require
the inclusion of

various ranges of typology. Generally each one of them responds to the personality and the attitude that each character develops throughout the course of the story. A character with heroic characteristics is usually the one in charge of performing the missions that require special physical feats. Based on this stereotype, that would be what is expected; however, we can play with all the elements and give that same type to another character that does not have sufficient capacity to use its strength properly and, as a result, fails when "its" abilities" are put to the test and thus becomes a funny character. The typology of each protagonist gives us the means for immediate identification, but there is always room to surprise the reader.

Analysis of the Distinct
Typologies

Obviously we wish our characters to be original, unique, and hard to copy and immediately recognizable by the readers for whom they are intended. In this chapter, we cover some of the most significant stereotypes that can be found in any story and that stand out for being good, bad, or secondary. A good creator is one who knows how to get the most out of each typology and turn it into something original and different, sometimes by simply telling the usual story in a different way.

Every character that appears in a story falls into a category type that defines the way it behaves throughout the story.

THE COLOR SKETCH

As a preliminary step to defining the stereotypes that we will see next, we will add a brief note regarding color and the inking of the protagonists.

It would be helpful to make some color studies of the characters that are created for the stories. This will provide greater objective perspective of the characters; they will look more lively and natural, and it will minimize the process if we are asked to do covers, posters, cards, or any other production or promotional material for our manga.

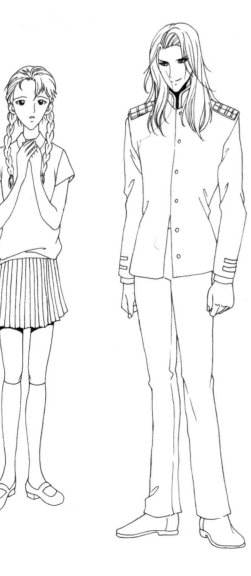

A simple test with markers, watercolors, or color inks can define what the characters will look like when they are done in full color.

INK STUDY

The same thing must be taken into consideration when the drawings are inked. A pencil sketch—even unfinished—usually constitutes a fresh, spontaneous, and very expressive approach. Sometimes, when it is inked without having done a previous study, that is "freehand," a perfect sketch can be compromised and its spontaneity and expressivity ruined. Therefore, before the characters are approved, it is important to confirm that once inked they will still have all the tonal values that we had anticipated. If necessary, study various inking techniques to emphasize the best features of each drawing.

In this example we can see the ink job over the pencil sketches from page 128. It is during this phase that the shadows and the small details are completed.

these include a wide spectrum of archetypes and styles in the world of manga. A protagonist can be male or female, and also a young adult, a child, and so on.

The Main
Characters

THE PROTAGONIST

This must be the most charismatic and central character of the story, upon whom falls all the dramatic content. At times he is motivated by his own actions, in others, by those of some villain that forces him into action in order to preserve the principles of order, generosity, and well-being.

The structure of a protagonist character is usually proportioned and conforms to the classical canons, depending obviously on the style that the artist is working in. The important thing is that the audience for which the manga is intended identifies significantly with it.

The possibilities are endless. We can find protagonists where some characteristics stand out more than others; in some of them it is their elegance and simplicity, or their charming personality and their desire to improve as well as their dedication, but in all of them the values are always positive.

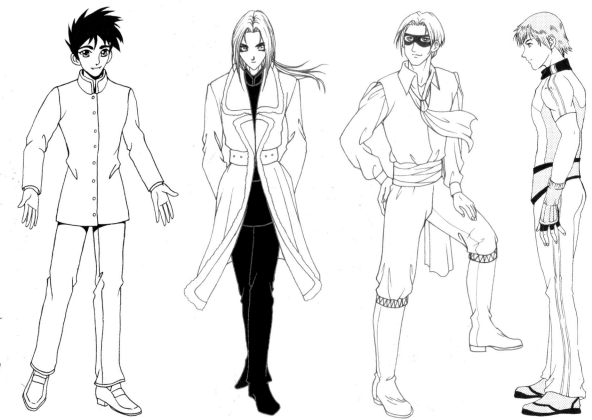

THE VILLAIN

It is difficult to imagine a story without the character of a villain; sometimes this figure is substituted for a negative situation in which the protagonist must use his ingenuity, his talents, and his charisma to reestablish order and peace. However, it is preferable for that situation to be instigated by a villain who is challenging and who makes things difficult. The villain is usually the most important character of the story. It is thanks to him that the conflict is established in the story and that most of the interesting situations are originated, since the mind of the villain is much more peculiar than the rest of the characters. The villain is the one who acts driven by his urge for domination, vengeance, his ambition for power, and his desire for destruction. In those cases, the protagonist responds to the situation created by the villain, who is after all the one who moves and carries the story.

Sometimes, the protagonists and the villains have the same goal in mind and fight with each other to achieve it. In any case, the interest of the story depends, in general, on how bad, strong, and powerful the character of the villain is, since he is the one in charge of putting the hero to the test and who gives the story its full dimension.

The purpose of all the formulas that appear in this chapter is to develop archetypes. The true creator is the one who extracts the essence of it all to create characters that are unique for their interest and graphic richness.

Example of the structure for the character of a villain.

A villain can be elegant but also macabre and even can be represented by a supernatural or mythological character.

A character with a heroic structure spans a height of nine heads of the classic canon of proportions, and he has the demeanor of a strong and resolute individual.

THE HERO

A heroic character usually represents the most positive aspects and must become a role model for the reader, either through his powers, his strength, his bravery, or his intelligence.

In Western comics, there is a very wide range of characters that are embodied by superheroes who face the dramatic barriers that form part of the story and who generally emerge victorious due to their power and ingenuity. In manga, these protagonist characters are not very common; in most cases the heroic characters play secondary roles or those of *cyborgs* and warriors and, depending on the plot of the story, act on the side of good or evil.

Even though manga has not approached the superhero genre in any special way, it is not difficult to find characters that have heroic natures in many of their stories, for example, the bodyguards of the yakuza and invincible warriors. Without a doubt, a wide variety exists.

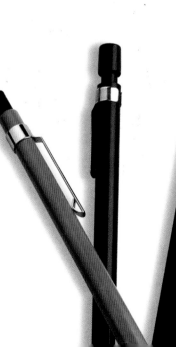

THE FEMALE CHARACTERS

These are the absolute protagonists in the *shojo* style, where the important thing is the way in which they suppress their feelings and give their love to the male protagonists of the story. But let's not jump to conclusions; in *shonen*, female protagonists can be true rivals of the strongest warrior, challenging them to great fights and sometimes even winning.

One thing that stands out in manga that is different from Western comics is the very important role that women have always played in the development of the plots. It is not by chance that manga for women has become a genre in its own right, or that in the other genres they share the roles of protagonists with the rest of the characters.

The proportions of a female character for a realistic manga follow the conventional canon of seven to eight heads. In the case of shojo, and as a result of the particular stylized and idealized tendencies of the genre, they can reach a height of nine heads.

Female characters have a very important role; however, their typology in general responds to the image of beautiful women or of young adolescents that have a mischievous charm. Obviously, we will find different types.

Magical, adventurous, evil . . . Manga recognizes a wide range of female characters.

CHILD CHARACTERS

These tend to embody the most charming aspects of a manga story, but it is not unusual for them to sometimes show their mischievous side.

In the *kodomo* style, children are the true protagonists, and in general they act in groups, even though one of the characters is the protagonist.

Their humor, friendliness, intellect, and ingenuity easily make up for the lack of strength or power of the protagonists of other genres. Their extroverted personalities help them find the necessary allies that have the physical characteristics needed to win over their antagonists.

Structure for a child character.

These characters stand out for their friendliness and ingenuity or for their supernatural powers.

THE PETS

It is not unusual to find pets as companions of a story's protagonist. They are conventional animals; although traditionally some of them embody imaginary creatures with certain powers that help the protagonists. Or they simply have a place in the story because they look so adorable.

To make pets a natural part of the story, they are usually given powers. Pets are the protagonists of most of the comic gags that take place in the story.

Layout of a conventional pet, although sometimes in the world of manga we may find some characters difficult to identify or to associate with any known creatures.

Example of the many possibilities for pet companions for a protagonist.

The Secondary

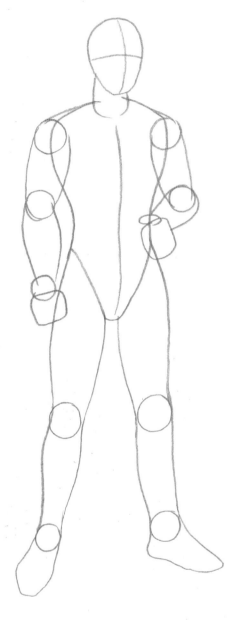

Characters

a secondary character could be a true protagonist in its own right; however, if there is already a well-defined protagonist, the secondary one could play the role of a good friend who helps bring out the human aspects of the protagonist, a child to help the reader see the softer side of the protagonist, a helper or assistant of the central evil character that shows the power and effectiveness of the protagonist in conflictive situations, a boy or a girl that reveals the most exciting or romantic aspect of the protagonist, and so forth.

Anything is valid to create potential ways to develop different avenues for the script that create continuity in the plot, and that at the same time emphasize certain aspects of the protagonists and that show them as real characters, with worries, feelings, and motivations.

Being secondary is not a reason for the characters to lack detail, moral qualities, and personality.

Possible layout for a secondary character. We must not forget that any other structure could work in this category.

A secondary character can attain true stature and trigger a situation in the story that the protagonist will later bring to conclusion. This is the reason why it is important for the secondary characters that have a direct relationship with the main plot of the story to have a well-defined attitude and structure. In general, manga also gives more importance to secondary characters than does Western comics. Probably one of the reasons for this is the length of the series, which sometimes spans thousands of pages. Without a doubt, this causes secondary characters to gain importance as the story progresses and to reach a dimension that is sometimes dangerously superior to that of the protagonist.

Secondary characters respond to any imaginable morphology and canon proportions. What is important is for them to be in the same graphic world as the rest of the characters that carry the story. In a realistic manga, for example, a secondary character responds to the conventional canons and proportions.

Different possibilities for secondary characters.

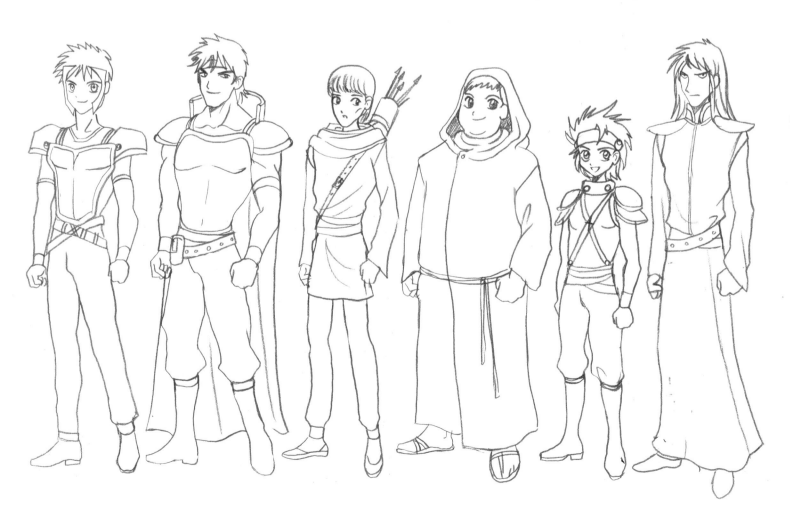

next, we will see some details that enhance the characters and that give them that "non-verbal expression" that makes them look real. It is vital for each character to stand out for their features, their expressivity, a gesture, or some specific "motions" (problematic in a static medium like manga, but easy to achieve with imagination). Certain elements of the character, such as his or her face, the hands, and the hairstyle, help give it dimension.

The Expression
of the Face

the face shows the most significant features of human expression, since it is there where the feelings and the inner world of the characters are reflected. In their faces we can see what they are feeling, what they think, and how they react to their surroundings. It is important to try out different expressions for the characters until we

find the most appropriate ones that fit what we wish to express. A specific expression may be more common of one character than another, but any face that we design must be planned with the idea that they will have to express multiple feelings throughout the course of the story.

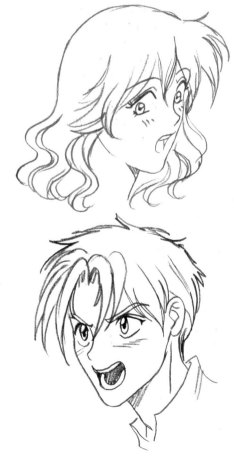

The face is the part of the body that best conveys feelings to the reader; therefore, it is important to study which factors make a face reflect the different feelings.

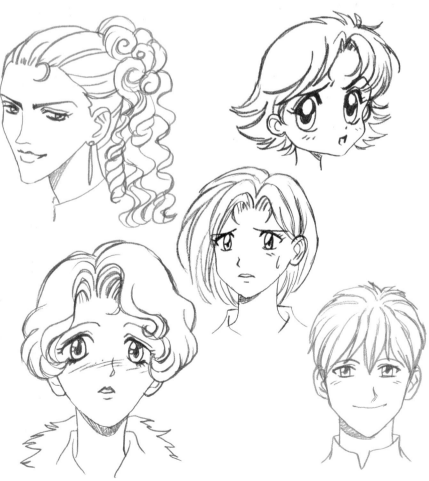

We must pay attention to the effect that some elements can have on others; for example, the eyebrows affect the upper part of the eye, while the cheeks affect the lower part. The artist will have to keep this in mind when he or she is drawing expressions on the characters' faces.

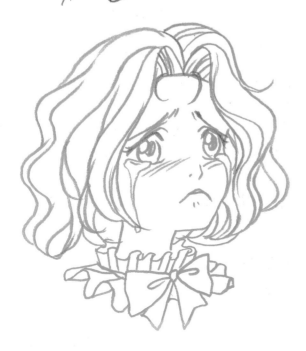

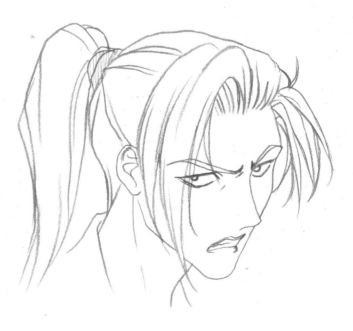

Drawing Hands
and Feet

the expressive potential of hands is as important as that of the character's face. The hand, because of its joints, is the part of the body with the greatest number of positions, and hands are used constantly in conversation and for any activity.

THE HANDS

The hands are also used to express a number of feelings. A character whose face is not visible but whose hands are clenched tightly against the thighs is showing the reader his contained anger, his lack of power to act at a certain moment, and his need to remedy the situation when he considers that the time is right.

Drawing hands is not an easy task, and some artists who are not good at it hide them in pockets or behind the character's back. It is better to practice and even not to be completely accurate, than to avoid the situation. With time and practice, the hands we draw will be able to express whatever we want.

Examples of hands. It is important to work with the hands of the characters until we find the gestures that make them more representative and characteristic.

THE FEET

These have very little or nothing to do with the expression of the characters. We could say that the feet do not tell us anything about the character; although that statement is not completely accurate. Obviously, the feet as such do not convey anything by themselves, but their pose does. The way a gentle and nice character places his or her feet is very different from the way a samurai ready to fight would. A short and close up drawing of feet moving forward could convey the mood of an approaching character. Therefore, knowing the anatomy of the foot and how to draw it and adapt it to the style used is also very important.

To draw feet, as with any other part of the character's body, we use round and oval shapes that serve as the foundation. We will use these structures to study the pose, the form, and the intention before we create the final drawing.

Studies of feet that attempt to define part of the demeanor of a character and adapt it to the graphic style of our work.

Outstanding Details
of Expression in Manga

Probably the shape and the sparkle of the eyes as well as the different hairstyles are two of the main characteristics that define manga drawings.

THE EYES

In manga the eyes depict several very particular characteristics. There are many theories about why the Japanese, whose eyes are almond shaped, have developed in their drawings such extreme eyes that are so removed from their own physical characteristics. Some claim that it is due to a complex, but nothing is further from the truth. One of the main reasons is the great influence that Western drawing styles had on Tezuka as an artist, influence that he in turn passed on to the rest of his fellow countrymen and women. This historical training, together with the particular demands of manga to convey feelings and emotions that are beyond any Western comic, relies on the extreme expressiveness of the eyes to fulfill that graphic requirement. Aside from theories, the truth is that the eyes of some manga characters show some particular traits that are worth studying and understanding.

In realistic manga, the eyes of the characters are much more normal and common than one might first imagine.

Huge irises and large pupils full of sparkle are a common characteristic, much more frequent in some styles than others.

To draw the eyes, we first make a sketch that defines their shape. In it we will broadly draw the most important details such as the pupil, the eyebrows, the eyelashes and others (A). In a second step we will profile the overall structure with the final pencil, smoothing out the details and highlighting the expression (B). Last, the drawing is finalized with ink. In this phase, we can bypass certain fragments of the pencil drawing that correspond to the contour of the eyes so it becomes more integrated with the rest of the facial features, and we will also pay special attention to the inking of the iris, the pupil, and its corresponding sparkle (C).

A B C

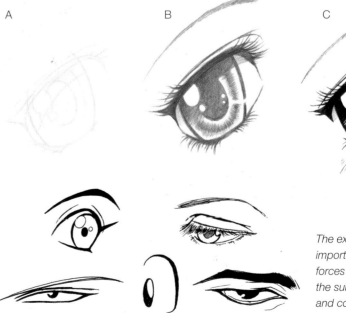

The expressive importance of the eyes forces the artist to know the subject extensively and comprehensively.

THE HAIRSTYLES

Another very important characteristic is the hairstyles of the characters. Not all of them have impossible hairstyles, some are very common, but they stand out for their attention to detail and their delicate finish. In other instances, we come across incredible hairstyles and showy colors. It is important to research this topic and to practice it since hairstyles are a very important feature for identifying a character.

The hairstyles of the characters are an important identifying trait of the manga style. Most authors pay special attention to detail and to the finish when it comes to drawing hair as well as to its color.

The diversity and variety of hairstyles is an important aspect to take into consideration. It is also necessary to decide which hairstyle is suitable for each character according to its personality and behavior.

The Setting

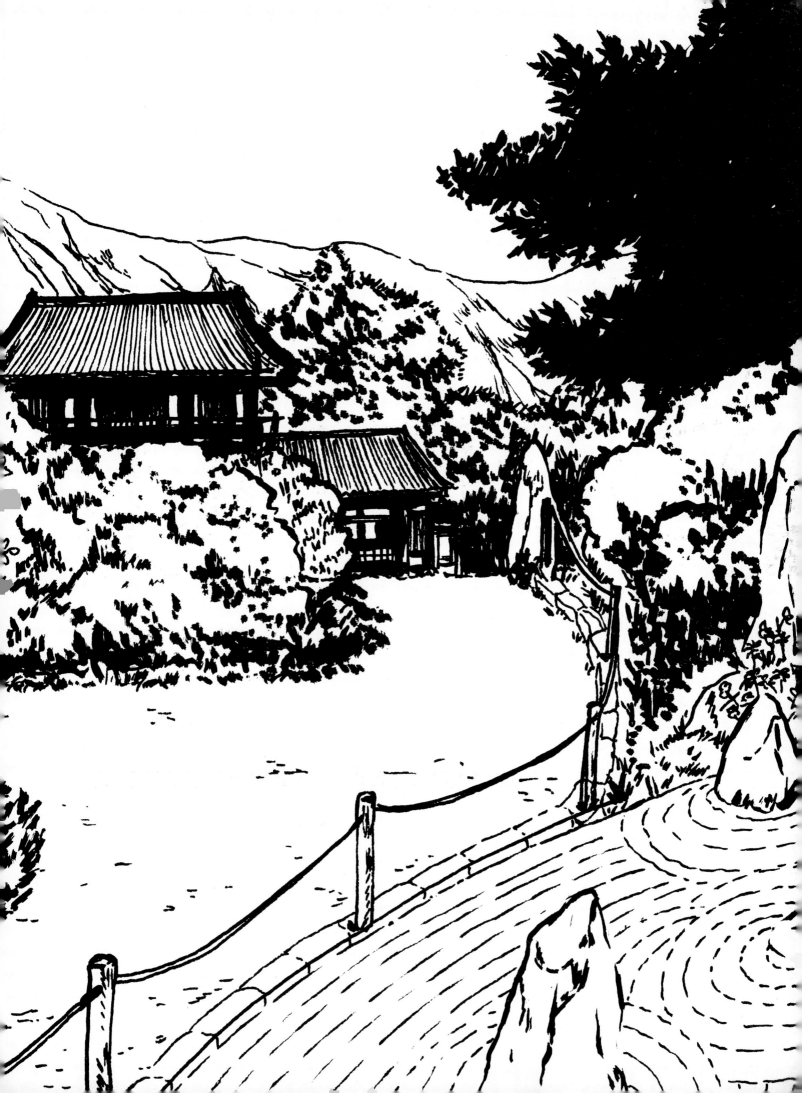

Drawing in

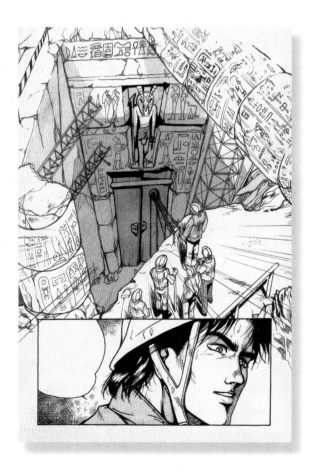

Perspective.

It surfaced for the first time

when Renaissance artists

came up with the concept and set the rules for perspective drawing. Without it there is no life, and no matter what type of drawing it is, it will lack realism.

A manga artist, as any other artist, does not need to have a deep knowledge of perspective, he or she simply has to be able to draw "what is seen," and, in general, it is done in a very intuitive way; however, a general knowledge, enough to help understand "what is seen," will be very useful in carrying out the work easily.

In the following pages we will cover some of the most important aspects to keep in mind when drawing perspective. Let us remember that, even though it is not essential to learn perspective in an academic setting, it is necessary to understand it and to approach it as a fundamental part of the work.

To Begin,
a Few Basic Concepts

before we begin explaining more complicated concepts, which involve geometry, we would like to define two terms: the horizon line and the point of view. Even though this is a matter of common sense, it is a good idea to analyze them and to reflect on the significance of their meanings.

THE HORIZON LINE

Every image has one: exteriors, interiors, objects, people, etc. The best way to understand it is by visualizing yourself on a beach facing the ocean. If you look straight ahead, without raising or lowering your eyes, you will see the horizon line in front of you, the separation between the ocean and the sky that is always in front of you, just at eye level. If you are standing, sitting, and even on top of some high place, the horizon line remains unchanged before your eyes, rising and lowering with you.

In our drawing, the horizon line, even if it is not as easy to perceive as the ocean example, is always at eye level. What we draw in manga can be above or below it. In the first case, the figures will be seen from below, in the second, the top of the objects will be visible.

The horizon line is in front of your eyes. If you lower your eyes, you will see the top of the objects.

In this case, you are looking straight ahead and at the same level as the objects, in such a way that the horizon line is also straight ahead in front of your eyes.

If you are at a lower level, the horizon line will not change, but if you look at the objects you will see them from below.

Anything that you draw, whether big or small, has its own perspective, from a complex composition like the human body to the smallest and most common object.

THE POINT OF VIEW

This is located on the horizon line, more specifically in the middle of the visual angle, when the spectator is looking straight ahead.

This does not mean that the horizon line and the point of view are the same thing, The horizon line is the line that can be seen with your eyes and that crosses the drawing from side to side horizontally. Looking ahead we can see it from right to left. The point of view, on the other hand, is a single and specific view and can be determined by directing the viewer's eyes up or down.

B

E

D

C

A

In this perspective demonstration we can see the following: point A is the model that the artist is going to draw. Point B is the chosen frame inside of which the artist is going to place his work. Point C is the horizon line. Point D is the point of view, and E is the angle or cone of vision that makes it possible to place the image inside an imaginary field.

In perspective drawing we use three vanishing points, which allow the artist to create a feeling of volume that produces a credible sense of reality. We must not forget that the work is done on a flat surface, paper, where the artist must resort constantly to perspective to create a feeling of three-dimensionality and to represent in the drawings the third dimension that every object has: depth.

The position of the artist with respect to the object or person that he or she is drawing will determine whether he will use one, two, or three vanishing points.

Vanishing
Points

PERSPECTIVE WITH A SINGLE VANISHING POINT

We will place two cubes perpendicularly to the horizon line. We can see one of their sides in its entirety from the front and their vertical and horizontal lines remain parallel. The effect of depth is achieved with a single vanishing point where the lines of the sides converge. The feeling of volume is not very strong making the model look a little bit static, which is ideal for many manga drawings.

In this perspective, the point of view is the same as the vanishing point. This characteristic does not hold true for the other perspectives that we will see next.

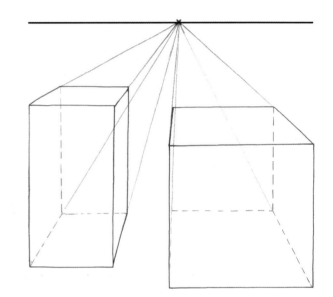

Perspective with a single vanishing point.

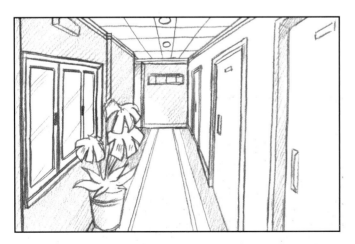

This is a good choice for representing scenes in which a specific symmetry is required. It is a good layout for giving the reader information about the scene. However, if we abuse it the result will be too restraining and unattractive.

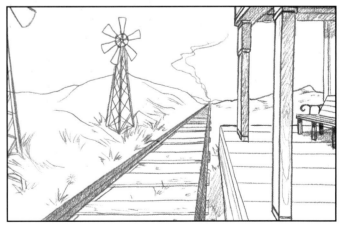

For a better example, imagine a scene with train tracks. The perspective with a single vanishing point gives us the feeling that all the lines that move away from the eye converge and meet at one point in the far distance.

PERSPECTIVE WITH TWO VANISHING POINTS

In this type of perspective only the vertical lines remain parallel to each other. The rest vanish into the horizon forming two series of lines that converge deep into their respective vanishing points. The image conveys a feeling of normalcy and perfection, and it allows the viewer to see bodies in a three-quarter view, making this the most commonly used perspective.

It is important that shadows be cast appropriately to fix objects in space and to support the sense of correct perspective. To make sure that this is the case, the following three points will be considered: the position of the point of light (A), the angle of the light (B), and the shadow's vanishing point in the horizon (C).

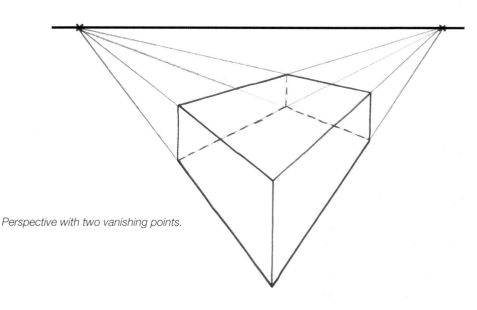

Perspective with two vanishing points.

This layout maintains the feeling of depth of the perspective with a single vanishing point, but it also makes the scene look more voluminous and natural.

This perspective describes the scene and the elements in it very well. It is generally used to describe any situation.

PERSPECTIVE WITH THREE VANISHING POINTS

In this case, none of the lines are parallel. They all converge in their respective vanishing points. As an important observation, you will be able to notice that two vanishing points are on the horizon line, the same as in the other cases, but the third one is above or below the line. This perspective is commonly used for advertisements because it shows the most spectacular view of the objects that are to be represented.

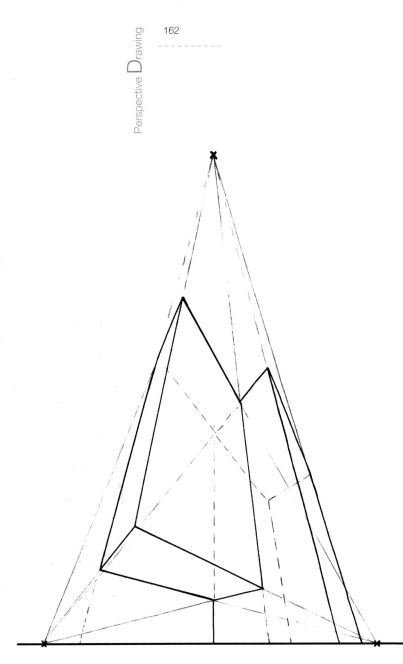

Perspective with three vanishing points.

This perspective depicts objects at an upward or downward angle. It can be used to provide a spectacular view of the scene and to convey a feeling of vertigo, danger, superiority, etc. It is also very descriptive of the surroundings and shows many details.

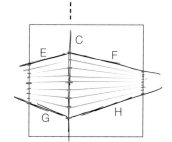

The typical scene of a large city can be represented with this perspective; however, due to its spectacular nature, it is better not to abuse it and to use it only when it is absolutely necessary.

There is a trick for drawing perspective lines when the vanishing points are outside the panel's borders. First, the main lines E, F, G, and H are drawn by eye. Then, you take one of the main edges, C, and divide it into equal parts. Divide the space between the lines on the margins of the paper into the same number of equal parts. When the marks are connected the perspective will be perfect.

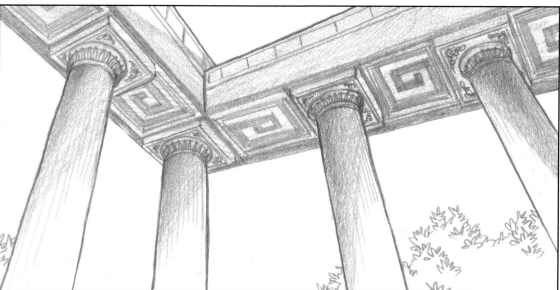

Example of a detail drawn with a three-point perspective.

Dividing Deep
Spaces

buildings, train tracks, telephone poles, trees perfectly lined up on each side of the road, and so forth, are challenges with which the artist is confronted panel after panel and which need to be solved in a simple but effective manner. We have seen how to work with three-point perspectives to create three-dimensional figures. Now it is a matter of creating the feeling of depth using those elements in such a way that the figures appear to become progressively smaller and closer together as they get farther away.

A

We begin by determining the center of the closest horizontal line, drawing a perpendicular line from that point (A) to the vanishing point.

Any succession of objects or figures that must look as if they were moving away in the distance can be drawn very effectively using this method.

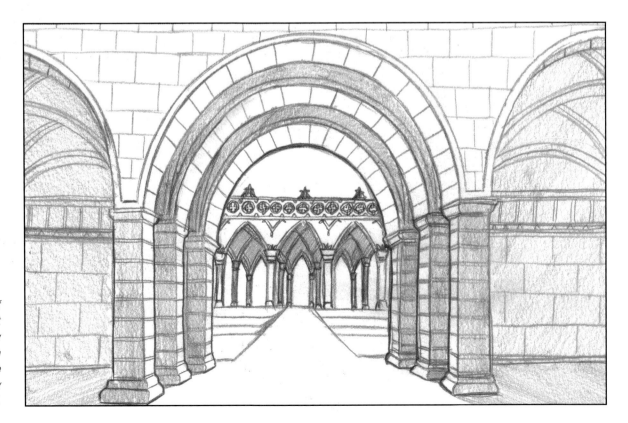

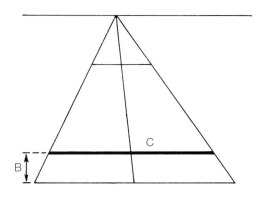

We calculate the depth of the first space B "by eye," drawing the first horizontal dividing line C that will represent the first railroad tie of the train tracks.

Dividing the space in depth will be very useful for all the parallel, horizontal, or vertical objects that seem to vanish in the distance.

Then, we will draw a diagonal line beginning at the vertex D and passing through the centerpoint E to find the point that will be called F.

The point F will be used to draw a new horizontal line G parallel to line C, which will be the second tie in perfect perspective with the previous tie. The center of this new line will give us the point H through which we will draw another diagonal that will begin at point I. Using this system repeatedly will allow us to find all the horizontal lines that divide the deep area into equal spaces, seen in perspective.

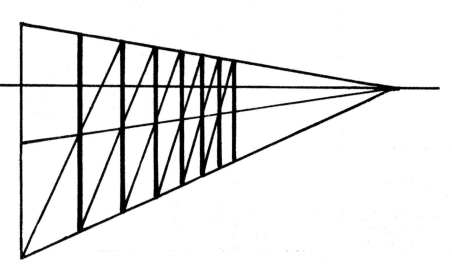

The method for dividing the depth into vertical spaces is exactly the same, and it can be applied to other applications to create any effects we want.

Backgrounds

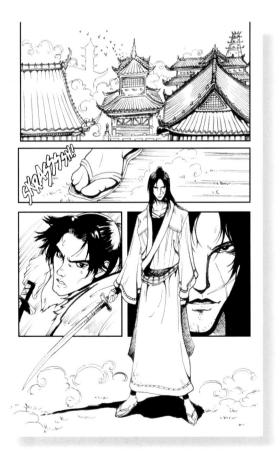

VANESSA DURÁN.
MUROMACHI, 2005

for the Cartoons,

that is to say, the settings

in which the manga takes place,

is very important. We have already seen part of that in the narrative chapter when we talked about the surroundings. As we said there, the setting provides the perfect context for the reader to understand the time frame in which the story takes place, as well as the location and the situation.

A detailed setting can provide a lot of information that is not told with dialog or descriptive text because this is a visual medium. Obviously, for some settings only a few lines are sufficient to convey the idea; for others just intuition will be enough. But whichever the case, the artist must always make sure that the reader is placed where the action occurs.

Perspective, as well as setting selection, lighting, and other factors that are equally important, will help us develop settings that are absolutely convincing for the story.

Different
Environments

The number of settings in which the story and the characters can be placed is endless, from common, everyday places, real and recognizable, to those which are part of fantasy, to totally imaginary and crazy. What is important in any case is the correlation between the story that is being told and the elements of the setting. We will cover the most relevant points to keep in mind by studying a specific setting and its surroundings. This will help you understand in a quick but clear way the settings that can be used in manga.

THE NATURAL SETTING
These are the settings that include natural elements: plants, flowers, trees, forests or jungles, and so on. The artist must do some basic research to be able to capture the essence of the basic elements of the setting that he or she is going to draw. The more detailed the story, the more precise the research will have to be. However, the most important thing is to find the appropriate vegetation that unequivocally will place the reader in that particular setting.

This setting would be ideal for placing the story in a Zen garden. It is a natural space that shows some elements of human interaction, including a house seen in the background.

THE ARCHITECTURAL SETTING

In this case it is very important to be able to draw in perspective because whether the settings reflect an urban environment with large city buildings, or a rural, traditional, or fantasy world, it will always be important to be able to convey a clear vision of it and to pay attention to all the details. The artist can do general research and then draw from his own experiences the designs of the buildings that will appear in the setting, unless the reader must be situated in a specific building that already exists, and of which the artist has to provide accurate details.

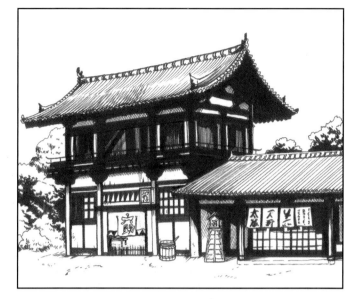

Near the Zen garden of the previous example, we find a traditional building that situates the reader in a specific setting. The time period in which the story takes place can be provided by the details of the surroundings and the clothes of the characters.

THE INTERIOR SETTING

Up to this point we have seen only exterior settings; however, interior settings are as important since the reader will find many details of the narrative in them. Lighting is a very important aspect because it defines the forms and helps us create depth.

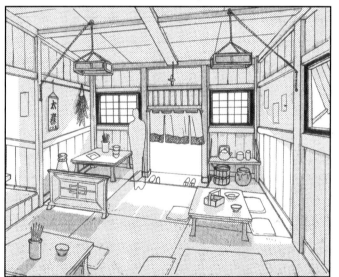

This building is a Japanese restaurant decorated in the traditional style. The story that would take place here could have different scenarios: an everyday story, a situation, a family story, a meeting of businessmen, or scheming yakuza gangsters.

BACKGROUND DETAILS

As part of the setting we can include details that will definitely help situate the reader and that will without a doubt provide much information about the story. In this case, it will be necessary to find out about all the objects that form part of the overall context.

We must draw all the elements that have a direct relationship with the story that is being told, paying special attention to detail.

light is not merely an aesthetic element. The relationship between light and shadow, and the way it is represented in the drawings, can also become a dramatic resource of great narrative value. To simplify, we will show how light and shadow affect the figure, but the characteristics of each type of lighting must also extend to the background.

Lighting
and the Use of Shadows

FRONT LIGHT

This type of light illuminates the model from the front, leaving the shadows practically hidden behind. There is very little feeling of volume and depth. Some artists barely illuminate their panels in order to give greater emphasis to the details of the drawing rather than to the dramatic effect. This tends to be a very common lighting method.

SIDELIGHT

This shines on the model creating an ideal feeling of volume and depth. It is the most common source of lighting, which is used to "explain" the forms and the look of the object or person.

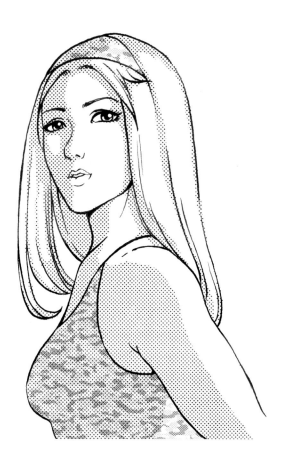

Sidelighting shows the volume of the model clearly.

Front lighting casts very few shadows on the drawing, takes away volume, but shows all the details.

BACKLIGHT

In this case, the light source is behind the model. The contour of the figure shows the characteristic halo created by this type of light. This method affects the volume negatively, but not the depth since it clearly separates the figure from the background making it look like there is space in between and creating a three-dimensional effect.

CENTRAL LIGHT

This creates a characteristic elongated shadow that provides volume but that has a negative effect on the features of the model. It is not commonly used unless the story that is being narrated requires it.

LIGHT FROM BELOW

This also produces a characteristic elongated shadow that extends upward, giving the figure an unreal, ghostlike, and sinister appearance. As with daylight, it must be used only in exceptional cases.

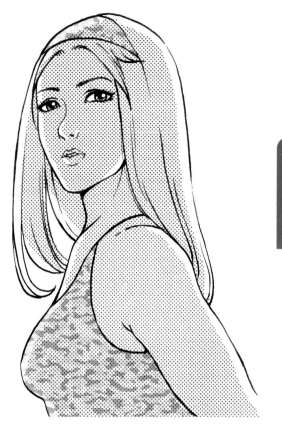

Overusing backlighting can tire out the reader, but its appropriate and timely use creates a good psychological impact when needed.

Daylight can be helpful to narrate very specific aspects of a story.

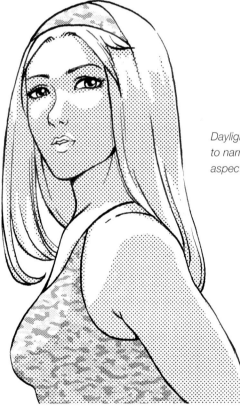

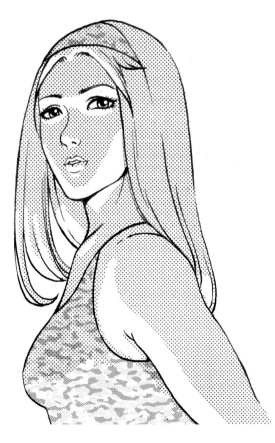

The lighting from below produces sinister and disconcerting images.

The Relationship Between
the Figures and the Background

every character must be drawn with the right perspective according to the surrounding in which it is placed. It is important to pay attention to the relationship between the sizes of all the figures, especially when drawing groups of people in the same setting. It is important to avoid making the figures look like they are floating, sunken, or drawn incorrectly.

THE CHARACTER AND THE SETTING

To make sure that the perspective of the characters agrees with that of the setting, we draw their corresponding perspective lines from their respective vanishing points. Those lines usually pass through the feet and the heads of the characters. The different heights of the people can be decided by taking into account the line that crosses the head of the character from a specific vanishing point.

Diagram of how several characters of different heights could be represented on a setting.

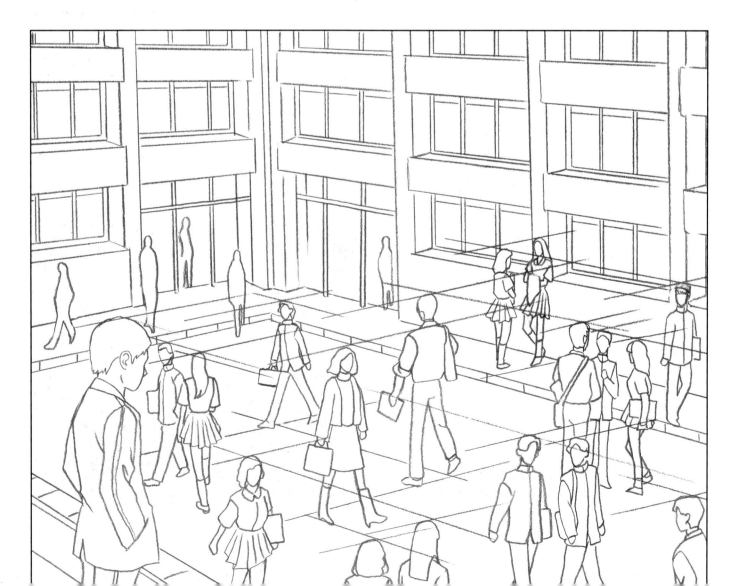

GROUNDING THE FIGURE

For the figures to look well grounded in their settings, the artist must take as his main reference the perspective of the feet on the ground, in the case of people, or of the base, in the case of objects and other elements. Aligning these perspective lines with the vanishing points serves to anchor the figures, avoiding the uncomfortable sensations of floating or being out of place.

By drawing the bases of the figures correctly, we make sure that they are properly grounded regardless of the distance between them.

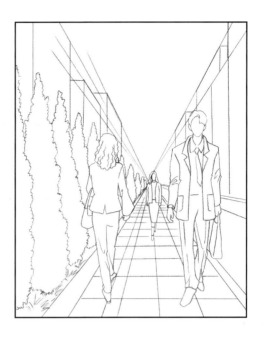

DEPTH BY ADDING ATMOSPHERE

In some settings, the distance between the various elements can be perceived differently according to the atmosphere that is between them. This phenomenon can be maximized by using thicker lines and darker hatching for the objects that are in the foreground and thinner lines and lighter hatching for those that are in the background. This will create an effective feeling of depth.

Depth can be created with a combination of the thickness of the lines and the intensity of the hatching.

DEPTH BY CONTRAST

Another way of creating depth is by using light and shadow properly and by contrasting the different depths of the drawing with different intensities.

By properly combining light and shadow, we can also create a strong feeling of depth.

The Work Process

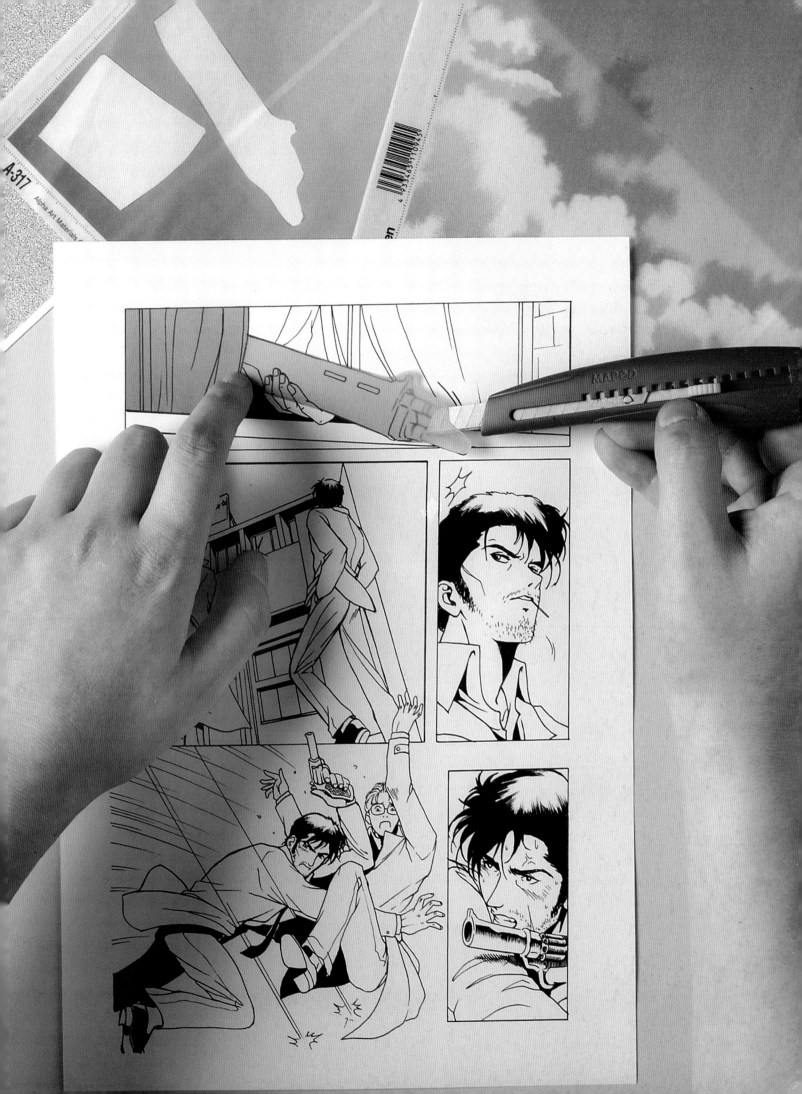

Creating the Layout
of the Page

before the final piece is created, the artist conducts several page and overall composition tests. At this stage of the process, the leading element is the script, and planning the layout beforehand will be useful for making the story fit into a specific number of panels, for studying and selecting the frames that best explain the story, and for trying out the different expressions and poses of the characters.

When we open a manga, what we see is two pages. In this preliminary stage the artist must make sure that the overall context of the story fits within the composition. He must also figure out a way to connect the most intense moments of the story with the last plate in order to capture the reader's interest and imagination to make him or her turn the page quickly.

At this stage the artist works with simple and quick studies. The work is practically a succession of sketches.

The idea for planning the layout beforehand is to provide the correct composition and the most effective panels for the script.

A light table is used to trace a panel that is considered perfect at the sketch stage. However, it is better to check each drawing carefully and, if necessary, redraw it so the layout is perfect.

THE SKETCH

Once the layout has been created, the story is developed panel by panel. We continue working with very simple sketches that give us a very approximate idea of what the final product will look like. At this point nothing has been completely decided, and it is a good idea for everything to be simple so it can be changed. This work is not done on the final paper, as this and the previous steps are developed on conventional paper. Only when something is completely acceptable will the artist go to the light table to trace it on the final paper.

The sketches help prepare the pages for the final pencil drawing.

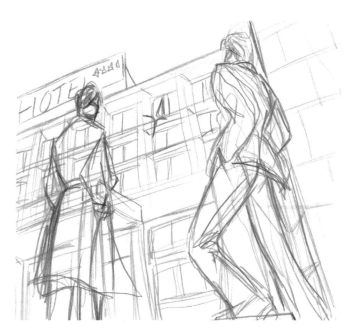

For this stage, the sketches are still simple but the figures, the perspective, the arrangement, and the overall composition are more defined.

PENCIL DRAWING

Everything must be very clear at this point. Through the previous steps we have been finding the best way to tell the story according to the script, and at this point we have chosen the frames, the correct order for the panels, and decided if we want to add or remove some of them. We begin to lay the panels out on the page, making decisions about the placement of the bubbles. We can use some elements from the sketching stage, but it is always better to redraw thom and to rearrange the sketches at that moment to make sure that they are constructed properly. It is better to do the work in pencil in a couple of steps; in the first one, we do the layout and the distribution loosely and preferably with a blue pencil or graphite that does not smear too much. In the second—having achieved all the objectives—we can go over each panel with the final pencil paying attention to the details, the expressions, and everything else that is needed.

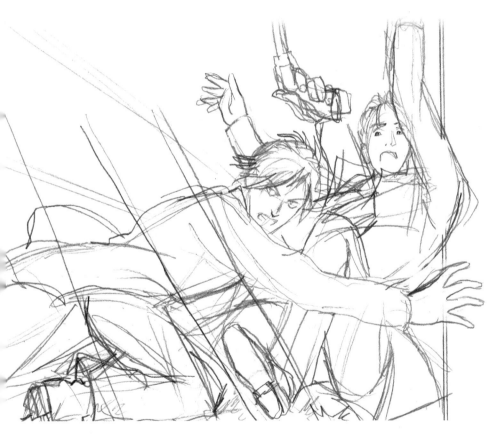

The pencil drawing is the foundation of the finished work; therefore, we must be convinced that we have achieved the desired result.

How a drawing is finished will depend on whether the artist himself does the inking or whether this is delegated to another person. We will have to pay more attention to details if we work in teams. The small "x" marks the areas that will be covered in black.

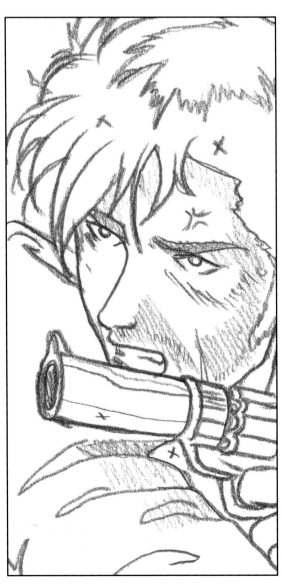

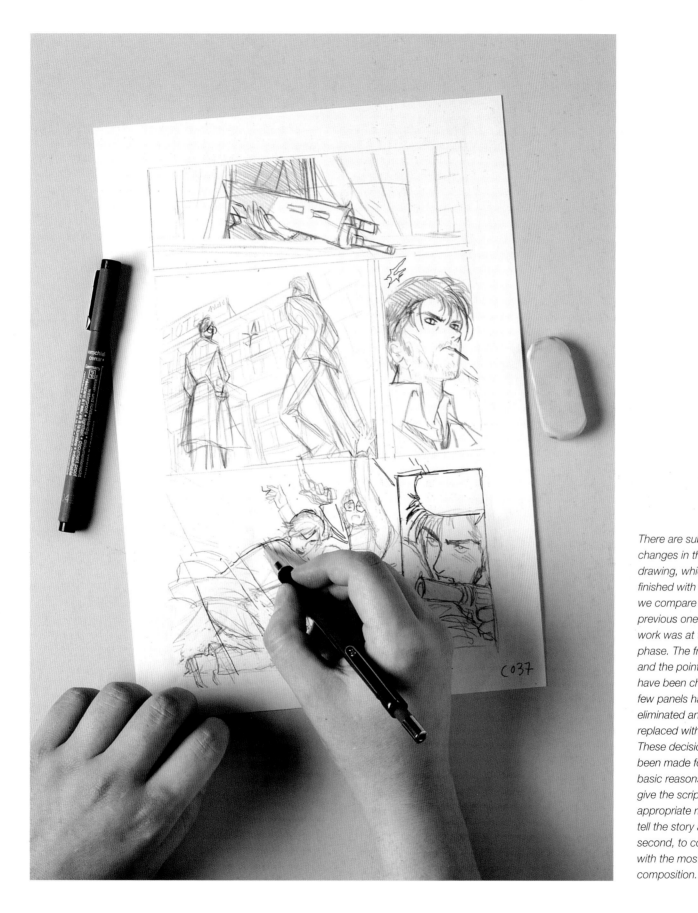

There are substantial changes in this drawing, which is being finished with a pencil, if we compare it to the previous one where the work was at the sketch phase. The framing and the points of view have been changed; a few panels have been eliminated and replaced with others. These decisions have been made for two basic reasons: first, to give the script the appropriate rhythm to tell the story and, second, to come up with the most suitable composition.

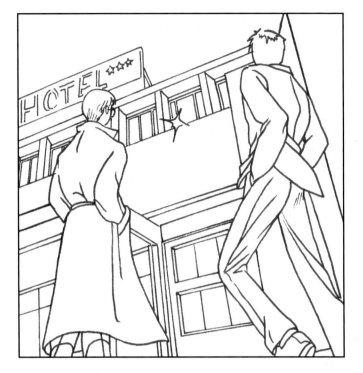

The first step of the inking process consists of drawing the main lines of the panels.

INKING

Special concentration and scrupulous care and organization are required to ink the pages. It would be very unfortunate to touch the wet ink with the hand and to make it smear, smudge, or to cause any other mishap that may ruin the work. The artist must work diligently when inking to make sure that the work is impeccable, especially now that the process is nearing the end and approaching the product the readers will see.

The common approach is to ink a page using several different techniques; we can use a nib pen or a thin brush, saving the thicker brushes and the markers for the black areas. The choices depend on the method that will produce the best results and the one that best corresponds to the artist's level of comfort and confidence. However, it is almost certain that in this step the artist will include some final effects, for example, lines scratched on solid black to show movement, dry brush effects, and splattering. One must not forget that to enhance the effect of volume, we can make a line of different thicknesses by controlling the pressure that is applied on the nib pen and the brush.

In the second phase the areas in black and some definite final lines are included.

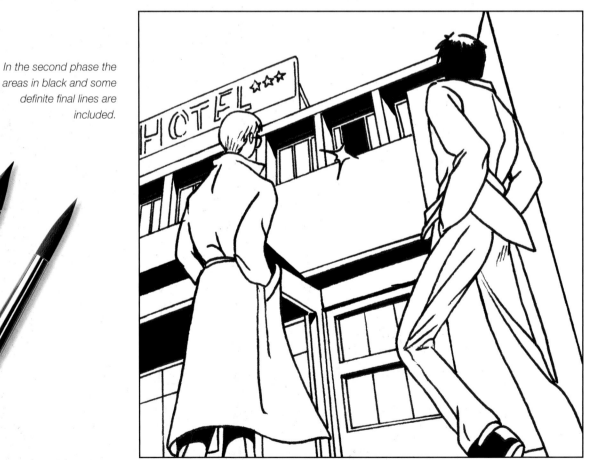

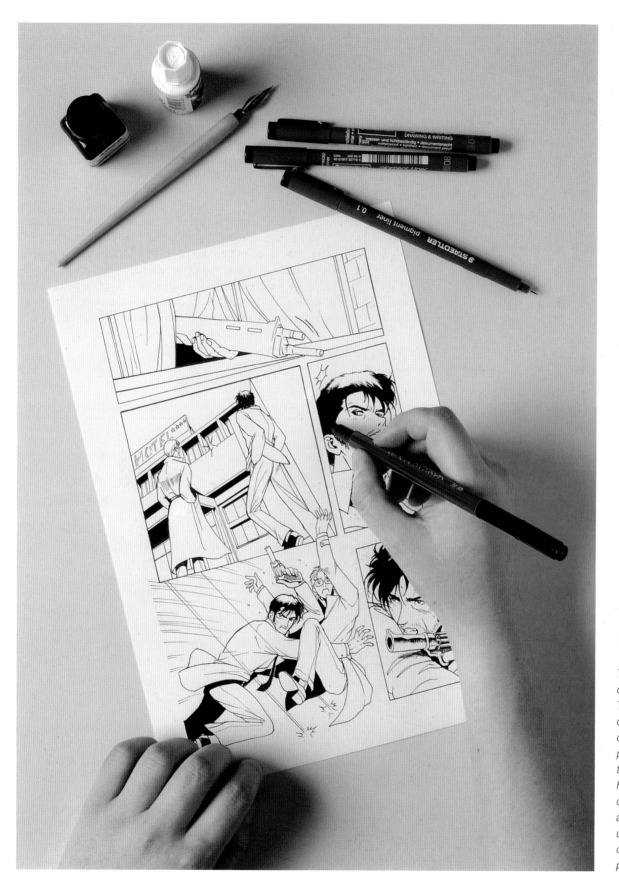

The final inking is done over the pencil drawing. This phase can be done right over the drawing on the same paper, keeping in mind that the pencil lines will have to be erased very carefully afterwards, or a light table can be used to ink the drawing on a different sheet of paper.

the way the story will look in the end depends on the technique used. In the chapter on materials, we saw the number of possibilities available for the different finishes, whether they are in black and white or in color.

We will continue with the page that we have been creating as a sample, and we will finish it with screens, probably one of the most common methods in manga after the simple ink finish with black contrasts.

Samples of adhesive screens that are available in specialized or art supply stores.

Finishing
the Work

SCREENS
There are transparent adhesive screens available that can be cut with a knife or scissors into any desired shape, but these screen tones can also be created on the computer. They are very useful for certain types of work.

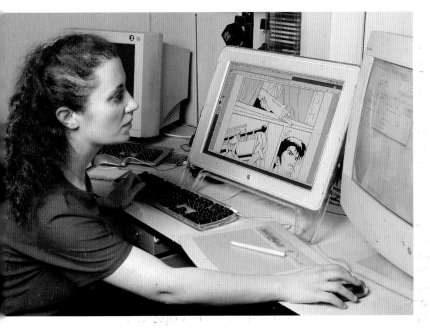

Using the computer to create screens.

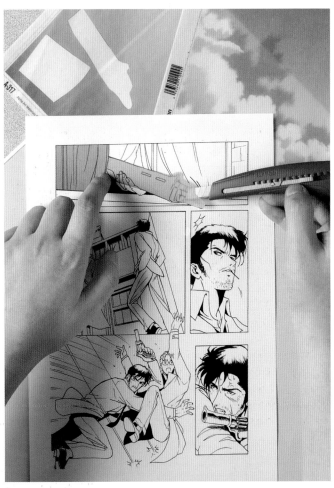

Placing screens on the original ink drawing.

The process for creating your own screen tones on the computer is not too difficult. There are special programs for it, but they can also be created with any regular graphics program that you may know and use. Simply experiment a little or consult a manual to find the best way to make them.

1

1. Original image drawn in pencil.

2

3

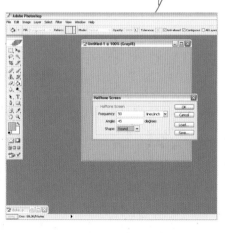

4

2. Begin with a high-resolution scan of an image, free of blemishes, making sure that all the lines of the areas that are to be covered with the screen are closed.

3. Open a scanned screen or create one of your own on the computer. For most of the graphics programs, you only need to create a surface at high resolution and to convert it into a bit map with the desired halftone frequency. Once the screen is visible define it as an object.

4. Return to the image and select the area where the screen is to be applied with the lasso or the magic wand.

5

6

6. You can do the same thing with the rest of the illustration and apply a complete screen over the drawing in a different style, denser, with more space, gradated, etc.

5. To fill in the previously selected area recover the screen and apply it over the original drawing.

7

7. You will be able to eliminate the part of the screen that is not needed with the eraser and apply the shading styles and shapes that you think are more appropriate.

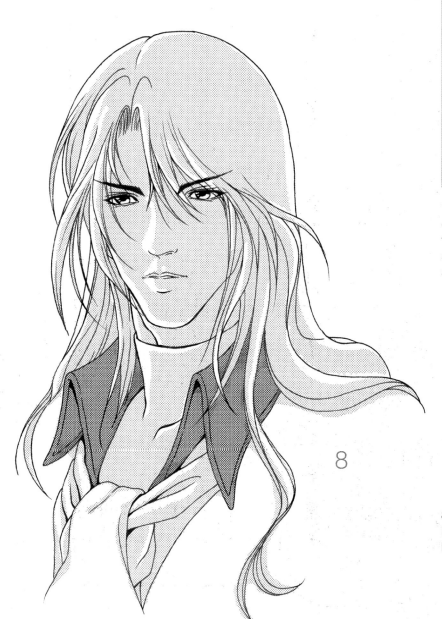

8

8. The result is very gratifying, and this is a very effective way of creating halftones on illustrations.

This is the finished result, using the processes necessary to create a black and white finish with halftones created with screens.

BANG
BANG

Other Finishing
Styles

Example of a panel finished with the wash technique.

Example of a panel finished with ink in the blocking style.

as we mentioned before, most of the manga published in Japan is in black and white and printed on different color papers that distinguish the stories from one another. However, artists use all types of finishes, including color.

BLACK AND WHITE

Washes can be used to create black and white works. Halftones are also possible depending on the proportion of ink and water charged in the brush. It requires mastery, but the result is very creative. Another option is to use markers in a wide range of gray tones. Black ink, by itself and applied directly, is a very common way to create a finish. This is referred to as "blocking," and it shows the areas in black, leaving out the halftones and the grays.

COLOR FINISH

We know that manga is generally done in black and white, but it is not uncommon to find some color, especially on the covers and in advertising products. Each artist has his or her predilection for one technique or another for coloring his work. Some favor markers; others work with brushes and use gouache, watercolor, or acrylics; and certainly others color their pages or covers on the computer, which can replicate any of the other techniques with excellent results.

The advantage of using the computer for coloring is that it is clean, fast, and easy to correct mistakes.

This illustration done on the computer shows its many possibilities. To create any type of work, the important thing is the previous experience and the results that have been achieved with other techniques. The results will always be the product of this experimentation and trial and error. Whichever the case, what matters in any finish is for it to be as close as possible to the idea that you initially had in mind.

Index

Bibliography

- Alfons Moliné, *El gran libro de los manga.*
Ediciones Glénat, Barcelona, 2002.

- Estudio Phoenix, *Cómo dibujar manga.*
Martínez Roca, Barcelona, 1998.

- Estudio Phoenix, *Curso avanzado del manga.*
Martínez Roca, Barcelona, 2001.

- Haruno Nagamoto, *Draw your own manga.*
Kodansha, Tokyo, 2002.

- AA. VV., *Cómo dibujar manga* (collection)
Norma Editorial, Barcelona, 2003.

Internet:

www.mangaes.com

www.wikipedia.org

www.wikipedia.es

www.japan.org

www.comic.de

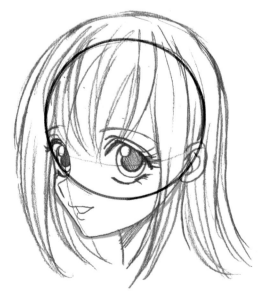

Acknowledgments

*I want to express my gratitude to Isabel and Julio, for encouraging me in this profession and for sharing their enthusiasm with me.
To my mother, for her comments and critiques, which helped me improve my drawing day by day.*

To Carlos, for giving me the software for the graphics and some of the drawing materials that I have used for my work.

To my colleague Sergi, from whom I have learned a lot on this project and because it has been a pleasure working with him.

To my editors, María Fernanda and Tomàs, who have given me all the creative freedom that I could have wanted.

To Christopher Hart, for his personal support.

And to all the people who have bought this book; I hope you enjoy reading it as much as I have enjoyed working on it.

Van

My gratitude to my children Gerard and Júlia, to my wife Lluïsa, to my parents Santi and Nuria, and to my in-laws César and Luisa.

To Florenci Salesas, Kenneth Figuerola, and Edgar Sicilia, my studio friends, who have "endured the labor" of this book as if they had worked on it themselves.

To my traveling partner Vanessa, for her dedication, her capacity for work, and because she has made this journey of nearly a year and a half very enjoyable.

To Alfons Moliné for his extensive work on books as well as magazines related to the world of manga, which have been of great help in the creation of this book.

To María Fernanda Canal, of Parramón Ediciones, for "getting me involved in this adventure" and especially to Tomàs Ubach, for his patience and for making me feel at home.

Finally, thanks to all the fans and authors of the world of manga with whom I have been in contact, for their suggestions, advice, and interesting points of view.

Sergi

Parramón Ediciones, S.A. wants to express its gratitude to D. Josep M. Figuerola, of Figuerola Belles Arts, pl. Mayor, 70-74 (www.figuerola.com) of Sabadell, for his collaboration in providing manga drawing materials to be photographed for this book.